Pu Quan

and his Generation

九夏清辰遂興長龍駒
荃匹直持驤並端浩劫
泂雲廢餘墨將傳之代頁
松窓居士遠作展　敬題一□
荃子圖主卷惜不見矣

啟功

Calligraphy by Qi Gong (b. 1910), imperial relative and fellow member with Pu Quan of the *Songfeng huahui* painting society, in honour of the exhibition of his paintings at the Ashmolean Museum.
Ink on paper, 175 × 58 CM

溥松窗先生及其宗人書畫作品展 啟功題耑

Pu Quan
and his Generation

Imperial Painters of
Twentieth-century China

Shelagh Vainker

and

James C. S. Lin

ASHMOLEAN MUSEUM

OXFORD

PU QUAN AND HIS GENERATION: IMPERIAL PAINTERS OF
TWENTIETH-CENTURY CHINA

THE ASHMOLEAN MUSEUM, OXFORD
10TH DECEMBER 2004–12TH MARCH 2005

The authors wish to express their thanks to
Qi Gong, Aixin Jueluo Wen Jia, and Miss Katy Talati

Text and illustrations © Copyright University of Oxford, Ashmolean Museum,
Oxford 2004

First published in the United Kingdom in 2004 by the Ashmolean Museum.
Publications Department, Beaumont Street, Oxford, OX1 2PH

ISBN: 1 85444 204 X

Shelagh Vainker and James Lin have asserted their moral rights to be identified as the
authors of this work

British Library Cataloguing in Publication Data

A catalogue record for this work is available from the British Library

Catalogue designed by Behram Kapadia

Typeset in Monotype Photina
Printed and bound by Cambridge University Press

The
Ashmolean

FOREWORD

The Ashmolean Museum is delighted to display the works of Pu Quan, cousin of the last emperor of China, and other members of the imperial family. It is a great honour to show their painting and calligraphy, and we express our thanks to the artist's daughter Aixin Jueluo Wen Jia for so generously lending so many works of art. The exhibition would not have come about however without the involvement of one of Pu Quan's former pupils, Oxford resident Miss Katy Talati, who has kindly lent paintings that Pu himself presented to her in 1948 on the eve of her departure from Peking. To both of them we express our thanks. We are also immensely grateful to Professor Michael Sullivan, not only for lending a magnificent landscape by Pu Quan's cousin Pu Ru who did so much to uphold the classical tradition of painting in the late twentieth century, but also for his continued support of the Ashmolean Museum; the exhibition will be held in the gallery for Chinese painting that opened to acclaim in 2000, and which is named for Michael and his late wife Khoan whom we remember with great affection. In the Ashmolean, I particularly want to thank the two curators, Shelagh Vainker and James Lin, who, sadly, has left the Museum to take up a post in Cambridge University. We wish him well. I should also like to thank Chezzy Brownen, Acting-Registrar. Finally I wish to thank the Art Museum, Chinese University of Hong Kong, and in particular the Director Peter Lam, for their generous assistance with the catalogue photography.

CHRISTOPHER BROWN
Director

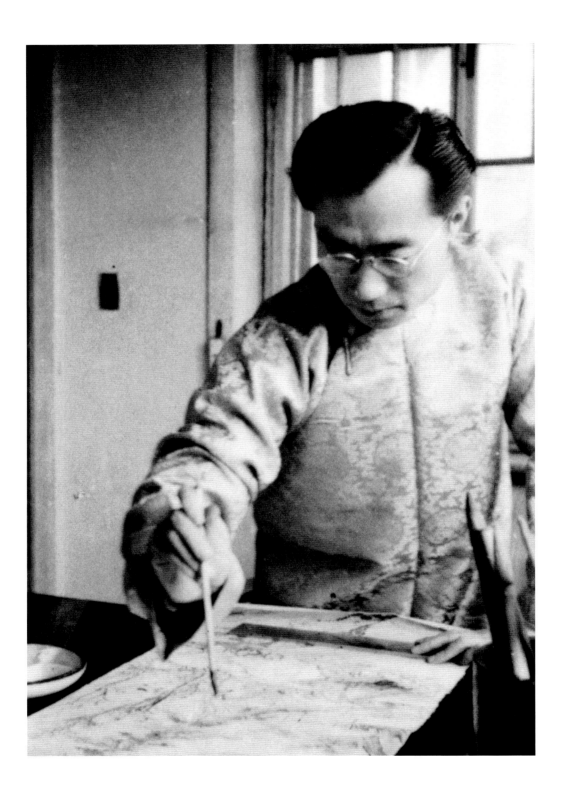

INTRODUCTION

Pu Quan was born two years after the fall of the Qing dynasty, a great-grandson of the Emperor Daoguang (r. 1821–50) and a cousin of Pu Yi, the last emperor. All the males of his generation of the Aixin Jueluo (Aisin Goro) clan bore names that included the character Pu, and several of them became well-known for their skills in painting and calligraphy.[1] The most famous was to be Pu Ru (Pu Xinyu, 1896–1963), who moved to Taiwan in 1949 and spent the rest of his life teaching and painting; he is known as the foremost upholder of the classical scholarly tradition of Chinese painting and calligraphy in the twentieth century. Pu Quan remained in Beijing all his life, and the paintings in this catalogue document his artistic career as a young prince of the imperial family, as a teacher in the Republican period, and as a member of a group of artists close to the political elite of the People's Republic of China.

As a child Pu Quan did not live in the imperial palace compound of the Forbidden City but grew up nearby in the Dongcheng district of Beijing. His maternal grandfather had been a member of the prestigious Hanlin Academy, while his grandfather on his father's side was renowned for his love of horses. The family always kept horses and Pu Quan himself made them the subject of many works (see nos. 12, 31) throughout his life. He learnt to paint at an early age, with help from his father and elder brothers, and when he was fifteen gave up formal education to embark on more serious studies of painting and calligraphy. Shortly afterwards, in 1928, he was invited to join the *Songfeng huahui*, or Pine Breeze Painting Society. The Society was one of many painting circles in Beijing at that period, and was distinguished by its membership being composed mostly of imperial relatives. The eleven members met at each other's houses to paint and to view paintings; they identified themselves by each taking a studio name that included the word *song*, meaning pine, which is how Pu Quan came to be known as Pu Songchuang. Both Pu's names were used equally and interchangeably throughout his life, though Songchuang is more closely associated with his painting activities than his birth name of Quan; additional names he used as a painter were Xuexi, Yaoxian and Jianzhai, all of which appear on his seals. The other ten members of the Songfeng Huahui were Pu Jin (Songfeng Zhuren, 1893–1966); Pu Ru (Songchao, 1895–1963); Pu Xian (Songlin, 1901–66); Pu Zuo (Songkan, 1918–2001); He Jisheng (Songyun); En Zhiyun (Guan Songfang, 1901–82); Hui Xiaotong (Songxi, 1902–79); Qi Gong (Songhuo, b. 1910); Qi Jingxi (1901–c.1944); and Ye Yangxi (Songyin). Only the last two were not related to the imperial family.

In addition to their work as individual artists, members of the society also produced joint and collaborative works (see nos. 10, 13, 14, 30), not just at the time of the society's existence in Beijing during the Republican period, but throughout their careers. The painting collection in Zhongnanhai, the compound adjacent to the Forbidden City that has been the residence of China's leaders since 1949, includes for example a landscape painted in 1951 by altogether nine artists of whom Hui Xiaotong and Pu Quan are two, and a bird and flower painting produced the same year to which two of the eight contributing artists are Pu Quan and Pu Xuezhai; another, depicting pine and cranes, is the work of Pu Quan and Pu Zuo.[2] In this way associations that had begun as part of an amateur family interest endured in a formal context under quite different circumstances.

Some time after joining the Pine Breeze Painting Society, Pu Quan became a member of the larger and better known Hu She, or Hu Society Painting Association, which was one of the leading artists' circles in Beijing in the 1920s and 1930s. Its principal figure was the foreign-educated Jin Cheng, and the society produced a monthly journal. Artistically, Beijing was the most conservative of the major cities at this period – in Shanghai a modernising movement had been active since the mid-nineteenth century while in Canton, painters were eagerly absorbing and adapting western techniques – yet Pu Quan's involvement with the Hu She indicates clearly that his painting and calligraphy were far more than leisure pursuits. Indeed, in 1936 he joined the Chinese Painting Research Society and in the same year began teaching at Fu Ren University.

Fu Ren Catholic University had been founded in 1925, established by two Chinese Catholic scholars and administered by American Benedictines, with the aim of providing an education in Chinese culture and Western science.[3] In 1936 a German rector was appointed and throughout the Japanese occupation of Beijing that began the following year, Fu Ren and Yanjing universities were the only ones that remained in the city, other higher education institutions having moved to the southwest of the country. Fu Ren operated with little change, and Pu Quan continued to teach there in the School of Education's Department of Fine Arts until the university was dissolved in 1952, its departments being transferred to a number of institutions but mainly to Beijing Shifan (Normal) University. In addition to teaching Chinese students at Fu Ren, including the very successful Betty Zeng Youhe Ecke, Pu Quan taught a number of foreign pupils in his own home. These included numerous embassy wives and the German Fritz van Briessen, who later published a book on the techniques of Chinese and Japanese painting illustrated with Pu Quan's didactic sketches.[4] One student however, following arrangements made by her mother, was taught by Pu Quan in her own home. This was Katy Talati, who had grown up in Beijing and to whom on her departure for England in 1948 Pu Quan gave a considerable number of his paintings and calligraphic works,

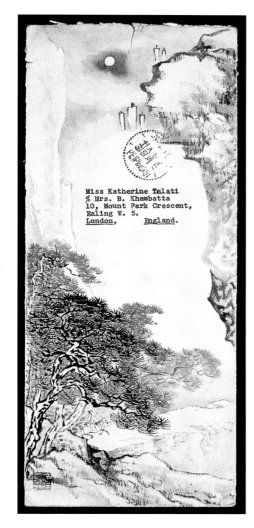

Envelope, painted by Pu Quan
with a scene of a moonlit
landscape with pine trees, and
addressed to Katy Talati.
Ink on paper

fearful of the political uncertainties of the time. Several are included in the present catalogue.

Prior to 1949 Pu Quan sold many of his paintings, largely to Japanese clients, but from that date until the early 1980s selling was not permitted; the first few years of the People's Republic were hard times for Pu Quan and other artists until 1953, when the Beijing Chinese Painting Research Society was established, providing them with a work unit. In 1956 Pu and other members of the Society were invited by the People's Liberation Army to produce a hand-scroll recording the Long March, in order to celebrate the thirtieth anniversary of the Army's founding as the Red Army. Those assigned to the landscape elements of the painting were taken on a trip retracing the Long March route and he spent the winter of 1956–7 in the mountains of Sichuan.[5] The journey was tough and had a lasting effect on his painting style, producing a more rugged approach that was a noticeable departure from the refined, 'indoors' style of his earlier works. During the Anti-Rightist Campaign the

following year in 1957–8, in which large numbers of artists and writers were accused of political crimes, Pu Quan was not labelled a Rightist though many of his friends and colleagues were. The early 1960s were spent fulfilling commissions for public buildings and teaching younger artists at the Beijing Painting Academy, as the Beijing Chinese Painting Research Society had become and in the second half of that decade, during the Cultural Revolution, Pu Quan was again relatively fortunate in his political treatment. For the most part he was regarded as politically unproblematic. In 1966 he continued to go to work at the Beijing Painting Academy though at one point he was not allowed to leave the Academy, where he was harshly treated. He was not detained there all that long but the criticism he suffered continued for a considerable period, during which he ceased to paint, but practised calligraphy.

He began painting again in the 1970s; many of his works were taken abroad as official gifts and in 1972 he met President Nixon in China. At the end of the decade, in 1979, he exhibited along with Wang Xuetao and others in Hong Kong at the Beijing Arts and Crafts Import Export Company, in one of the first post-Cultural Revolution art exhibitions outside China. He became a representative on numerous artists' committees and in 1985 was invited to join the prestigious Zhongyang Wenshiguan, an association of leading figures in literature and the arts. Some years later his works, long included in museums and official buildings within China, were also shown in Japan and occasionally in smaller exhibitions in the West.[6] He continued to paint until almost the end of his life and it is notable that in these later works, despite the emboldening of his style in mid-career as a result of retracing the steps of the Red Army, Pu Quan returned to the subjects of his youth, depicting horses, pine and bamboo in the strong palettes he had favoured as a young member of the Songfeng Huahui in the company of his cousins and brothers.

1 Li Zhiting, ed., *Aixin Jueluo jiazu quanshu* (10 vols.), Changchun (Jilin renmin chubanshe), 1997 – vol. 10 includes painters and calligraphers, see p. 105 for a family tree; Jiang Yuanwei and Sui Hongyue, *Aixin Jueluo shi de houyimen*, Shanghai (Shanghai renmin chubanshe), 1997; Beijing shizhengxie wenshi ziliao weiyuanhui, ed., *Xinhai geming hou de Beijing manzu*, Beijing (Beijing chubanshe), 2002.

2 *Zhongnanhai zhencang huaji (Paintings from Zhongnanhai's Collection)* 2 vols., Beijing (Xiyuan chubanshe), 1993, nos. 1:2; 1:17; 2:128.

3 Chen, John Shujie, *The Rise and Fall of Fu Ren University, Beijing: Catholic Higher Education in China*, Routledge Falmer Studies in Higher Education, New York (Routledge Falmer), 2004.

4 Van Briessen, Fritz, *The Way of the Brush: Painting Techniques of China and Japan*, Tokyo (Tuttle), 1962.

5 S. Vainker, 'Landscape and Revolution: Paintings by Dong Shouping (1904–97) in the Ashmolean Museum', *Apollo*, November 2002, pp.36–41.

6 In China these include the Chairman Mao Memorial Hall; Tiananmen; the Great Hall of the People; Zhongnanhai; Diaoyutai Guest House; China History Museum; Zhongyang Dang'anguan; China National Gallery; Zhongyang Wenshiguan; Beijing Painting Academy.

The Catalogue

1

Pu Xinyu
1896–1963
Landscape

Before 1949
Ink and colour on paper
122.4 × 37 cm
Khoan and Michael Sullivan Collection
Published: *Modern Chinese Art: The Khoan and Michael Sullivan Collection, Oxford* (Ashmolean Museum), 2001, no.95
Inscribed: 結茅傍山壑　入山生遠情　千峰霽微雨　孤館有餘清
　　　　　灌木滋眾綠　奇芳袁空榮　駕言采薇蕨　晨夕空山行
Seals: 溥儒; 省心齋

Pu Xinyu was, like Pu Quan, a great-grandson of the Emperor Daoguang (r. 1821–1850) and a member of the *Songfeng huahui* (Pine Breeze Painting Society). He was born in Beijing, and studied in Berlin and spent some time in Tokyo; he returned to Beijing for some twenty years but in 1949 he left to live in Taiwan. There he spent the remainder of his life painting and teaching, and he became the leading twentieth-century exponent of classical painting style. This painting was exhibited in 1949 in Shanghai, and is a fine example of early twentieth century orthodox composition and techniques.

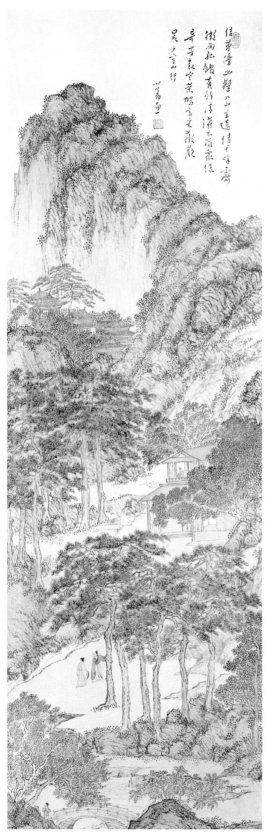

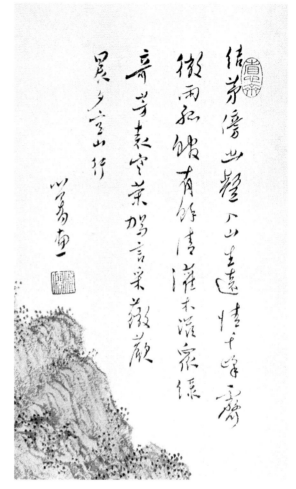

2

Pu Quan
1913–1991
Autumn landscape

1940s
Ink and colour on paper
82.2 × 31 cm
Katy Talati Collection
Signed: 溥伒
Seal: 溥伒長壽

This small painting of a rider in mountain scenery is a rare example of Pu Quan's early landscape style. The composition is dense and the brushwork careful, as in his flower paintings. The reds and browns indicate an autumn scene, and the generally bold use of colour is unusual for a landscape in such traditional style. It is painted on paper which is almost certainly of some age, for Pu Quan used papers and silks from the imperial storehouse and his preference was for old materials.

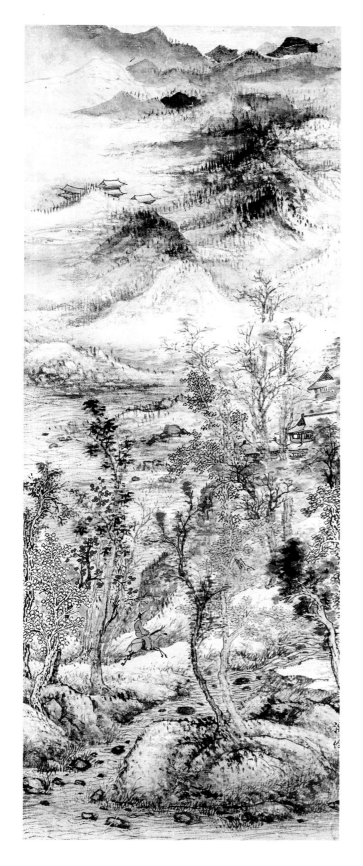

3

Pu Quan
1913–1991
Landscape

1940s
Ink and colour on silk
253 × 53.7 cm
Katy Talati Collection
Signed: 溥佺
Seal: 溥佺長壽

The landscape uses the structure and techniques of highly traditional painting: the viewer can read a path through the scenery from the foreground to the mountain heights, while fine brushwork has been used for the trees and figure, and broader strokes for the rocks and water. The painting is executed on silk, which requires careful rather than spontaneous use of ink. The colours, though typical of Pu Quan's work, are unusually strong for such a traditional landscape: the buff is vivid while the pale green is bright, and extensively used in a way generally seen on archaistic landscapes that revive the blue and green mineral palettes of Tang dynasty painting. Pu Quan had access to the imperial stores of painting and writing materials. He favoured old paper, silk and ink, and the silk support for this painting probably dates from the later part of the Qing dynasty. The silk of the landscape in catalogue number 4 is thought to be early Qing or possibly even late Ming, while a much smaller landscape handscroll (not exhibited) also in the collection of Katy Talati was said by the artist to have been painted on Song (960–1279) dynasty silk.

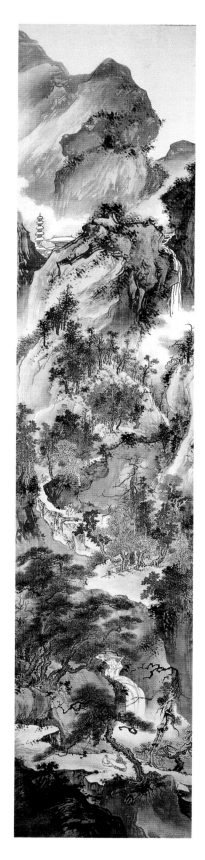

4

PU QUAN

1913–1991

Rich and wonderful streams and mountains

1946

INK ON SILK

44 × 742 CM

KATY TALATI COLLECTION

TITLE: 溪山深秀 戊子長夏雪齋題

SEALS: 1. 溥伒長壽; 2. 山可一盦青

INSCRIBED: 溪山深秀圖

丙戌九秋擬宋人畫法

松窗居士溥伒寫於琴書堂中

SEALS: 1. 溥伒長壽; 2. 松窗居士

COLOPHON 1: 南去青山冷嘆人

樓頭珍重苦吟身

世間歲月關興廢

唯有烟霞萬古新

戊子六月坐紫幢寄廬讀松窗居士畫卷心神俚暢因拈舊句於後

元白居士啓功

SEALS: 1. 蘭靖 堂; 2. 啓功之印; 3. 元白居士

COLOPHON 2:

展卷豁然令神王	西山深秀何爽曠	筆端造化能移情
高人聊寫胸中藏		
南宗北宗均妙喻	堪笑耳食刻舟訪	王孫風流映江湖
寢饋六法憂樂忘	上下古今擷眔妙	慘澹經營意爲上
固知書畫有精義	創意造境情景漾	筆墨情景貴相發
粗俇纖弱皆蔽障	真放精微同一理	平正險絕共積釀
豈許優孟作孫叔	未宜醜鄙稱雄強	圓頓悟入方得髓
步趨皮毛寧非傖	情景筆墨融於一	神遊寥廓獨翱翔
伯屏　楊宗瀚		

SEALS: 1. □; 2. 楊; 3. 伯屏印章

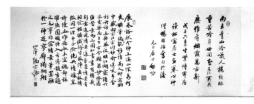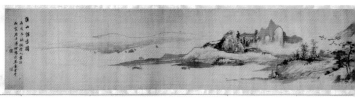

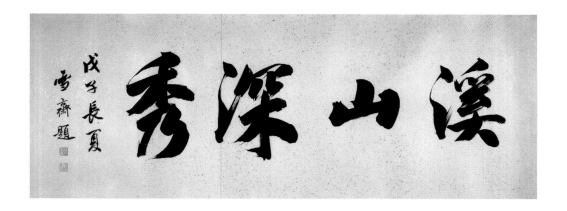

This work includes a title added by Pu Jin (1893–1966) in 1948, a colophon by Qi Gong also written that year, and a much longer colophon, undated, written by Yang Zonghan. Pu Quan's own inscription includes the landscape's title and the comment that it was painted in the style of Song dynasty artists, in 1946, at his studio the Qinshu Tang ('hall of lutes and books'). The colophon of Qi Gong mentions that names and titles are transitory, while paintings last forever; that of Yang Zonghan is a poem evoked by the landscape.

Though Pu refers to artists of the Song dynasty (960–1279) in general his style here is very much that of Southern Song (1127–1279) painting, in which strong ink lines are complemented by extensive areas of ink wash, and compositions tend towards emptiness rather than density. Southern Song landscapes are noted for their decorative qualities in contrast to the earlier more fluent, calligraphic styles of Northern Song (960–1127) landscape, and are often, as here, painted on silk. This style of landscape was prevalent at the imperial court of the Southern Song dynasty, an association which may have influenced Pu's stylistic preference in this work.

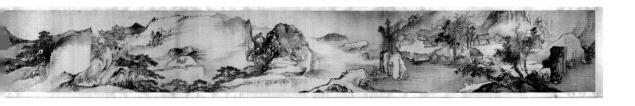

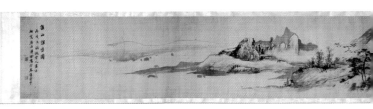

南去青山泠唤人楼頭珠
重苦吟身世間玄月冥興
庚惟宥烟霞萬古新
戊子六月生紫幢寄座
讀松窻居士畫卷心神
但暢因拈窋句於松後
元白居士啟功

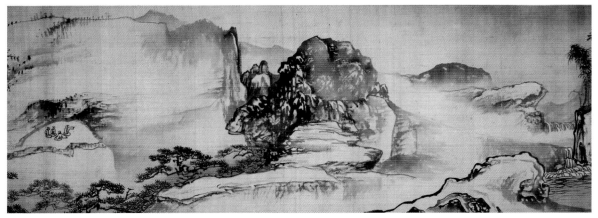

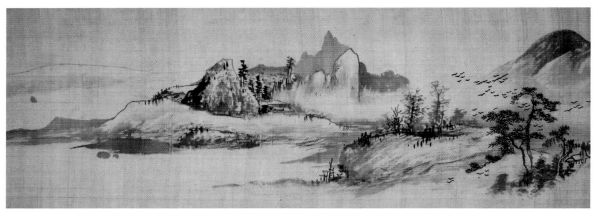

展卷髣髴令神王溪山深秀竹
爽曠筆端能移情高人卿寫胸
中藏南宗北宗均渝湛笑身食
刻前訪王孫風流映江湖霞鎖六
決處藂忘上下古今掬泉妙慘澹
經營意為山圓知書畫有精義
劍鈹粗獷織躍駒時藏障真放精
相敠造境情景漾景墨情景貴
微同一理平正險絕共積釀宣
許優孟作叔永宜魄梅
雄強圓塊悟入方得髓步趨
炊元寧非館情景獨翰翔
於一神遊夐廓獨翰翔
伯厚楊宗瀚

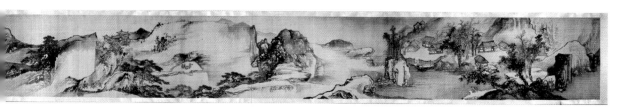

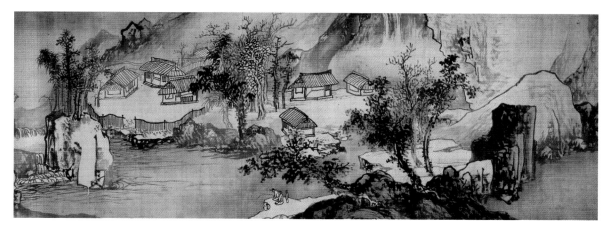

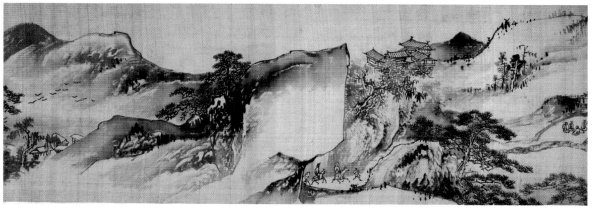

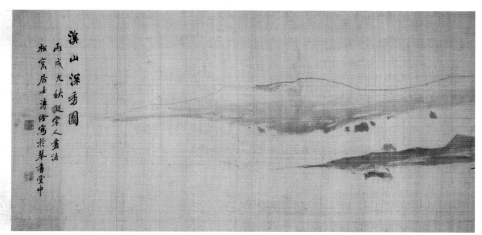

南去青山泠唤人楼头琭

溪山深秀圖
丙戌九秋擬宋人畫法
賴實居士溥佺寫於柴草書堂中

5

Pu Quan
1913–1991

Camellias and rock

1948
Ink and colours on gold paper
36 × 58.6 cm
Katy Talati Collection
Inscribed: 戊子春(之)正月　松窗居士溥伒製
Seals: 溥伒長壽;松窗

Pu Quan's flower paintings are very rare and were painted mostly before the Chinese Civil War. This painting dates to spring 1948, a year before the Communists reached Beijing. It depicts white and red camellias growing behind a rock, which is painted in blue. The front and back leaves of the camellias are represented by turquoise and deep blue respectively while the red, white and deep blue create a bold contrast with the gold paper. The decorative style was inspired by the gold and green landscapes of Tang dynasty court artists.

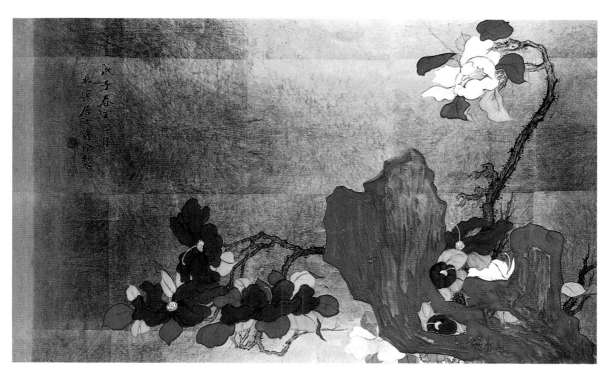

6

Pu Quan

1913–1991
Camellias and pine tree

c.1948
Ink and colours on paper
90.5 × 30 cm
Katy Talati Collection
Inscribed: 松窗居士溥佺
Seals: 溥佺長壽；松窗居士

Camellias and pine trees are usually depicted together in Chinese decorative art, as they represent the term *changchun* (evergreen or longevity). Both camellias and pine trees in this painting are arranged at the left-hand edge and stretch to the right. The red camellias are the main focus of the painting. The pine tree at the top right corner and the branch of white camellia at the bottom are arranged to balance the red camellias in the composition.

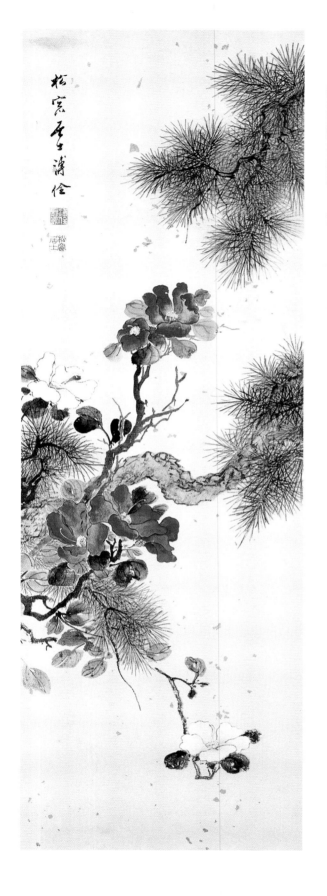

7

Pu Quan
1913–1991
Peony

1948
Ink and colours on paper
30.5 × 41.5 cm
Katy Talati Collection
Inscribed: 三十七年八月十八日舜明女士壽　松窗溥佺寫祝
Seals: 溥佺長壽; 松窗

This white peony was sent by Pu to one of his favourite students, Katy Talati, and is precisely dated to 18 August 1948, her birthday. The delicate white peony and butterfly are executed in colour instead of traditional ink and the style is reminiscent of the work of the great Qing painter, Yun Shouping (1633–1690). The peony was the national flower during the Tang dynasty (618–906) and is symbolic of wealth; however, when painted for a lady, it can also be viewed as a token of affection.

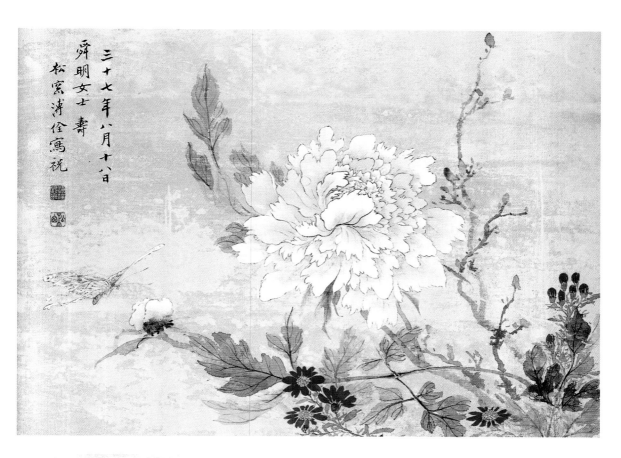

三十七年八月十八日
舜明女士　壽
松窠溥佺寫祝

三十七年八月十八日
舜明女士　壽
松窠溥佺寫祝

8

Pu Quan

1913–1991

Lotus

c.1948
Ink and colours on paper
42 × 38.5 cm
Katy Talati Collection
Inscribed: 松窗居士溥佺
Seals: 溥佺長壽；松窗居士

The lotus is a typical seasonal flower which blooms in mid summer, June and July. It was particularly appreciated by the Northern Song scholar, Zhou Dunyi (1017–1073), who wrote a famous article describing how the lotus grew out of the mud, yet its flower was pure, fragrant and elegant; he made it a metaphor for a gentleman. Since that time the lotus has been a popular subject in literati painting. Pu Quan's lotus was given to Katy Talati around 1948.

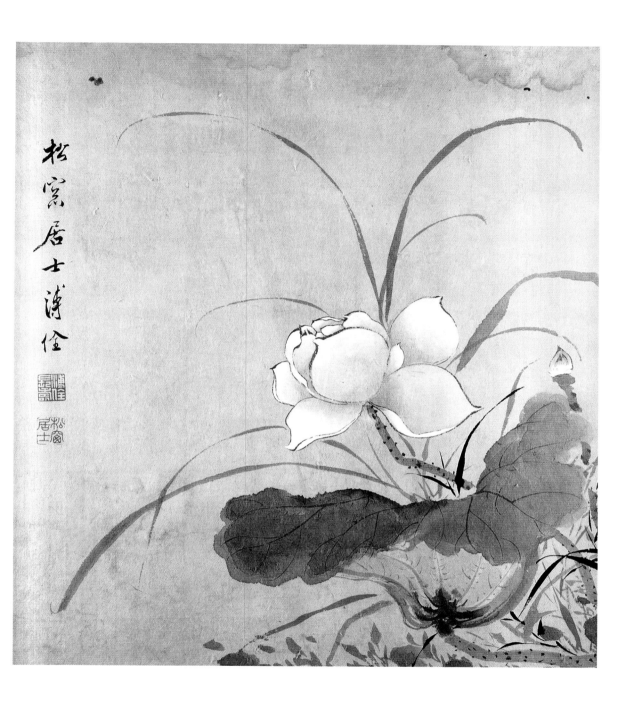

松窗居士溥佺

9

Pu Quan
1913–1991
Horses with groom

c.1948
INK AND COLOURS ON GOLD PAPER
19.5 × 53.5 CM
KATY TALATI COLLECTION
INSCRIBED: 溥佺
SEAL: 溥佺長壽

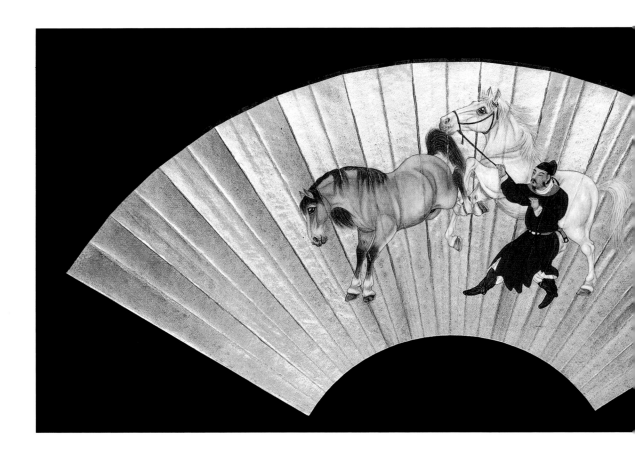

The horse was the first subject Pu Quan depicted when he started painting at the age of five. He learned from his father, imitating his paintings, and was later influenced by his elder brother Pu Jin (Xue Zhai); eventually he sketched the horses from the family stable. The horse is a favourite subject for scholars because it served as an analogy for every sort of career that a scholar might have.

This painting depicts a groom in red livery trying to tame two horses and seems to be inspired by Li Gonglin's (c. 1041–1106) handscroll *Five Horses* and Zhao Mengfu's (1254–1322) *Horse and Groom*.

PU XINYU
1896–1963

HUI XIAOTONG
1902–1979

QI GONG
1910–

Landscape

1940S
INK AND SLIGHT COLOURS ON PAPER
24 × 72 CM
PU QUAN FAMILY COLLECTION
INSCRIBED: 敬求法繪　賜款松窗
1. .松巢溥儒爲弟松窗作古寺浮圖
2. 松窗主人雅教　松溪惠均作平疇懸瀑
3. 啓功用夏圭法寫山石
SEALS: 1. 心畬; 2. □; 3. 啓功

This landscape is a collaborative work by Pu Xinyu, Song Xi (Hui Xiaotong) and Qi Gong, and was commissioned by Pu Quan, all members of the Pine Breeze Painting Society, which was founded in 1925. Pu Xinyu painted the temple and pagoda while Song Xi painted the waterfall and Qi Gong painted the rocks using the style of Xia Gui (c. 1180–1230). Although there is no date on this painting, it must have been produced in the period when the artists were all members of the Society, before Pu Xinyu left for Taiwan in 1949.

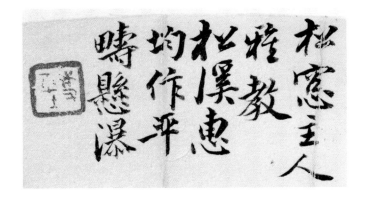

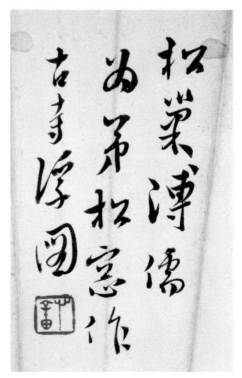

松栞溥儒
為弟松窗作
古寺浮圖

啟功用夏圭法寫山石

11

Pu Jin
1879–1966
Horse

Ink and colours on paper
19.5 × 51 cm
Ashmolean Museum ea 2002.111, Given in honour of Angelita
Trinidad Reyes
Inscribed: 雪齋溥伒畫
Seals: 溥伒長壽; 雪齋書畫

Pu Jin was skilled in most of the traditional genres of literati painting and
particularly famous for his horse paintings. Although his techniques are
based on Chinese styles, he was adept at painting horses in the Sino-Western
style developed in the 18th century by Giuseppe Castiglione (1688–1766),
Jesuit painter at the Qing court. Pu Jin was also the key artistic influence on
Pu Quan's horse paintings.

PU QUAN

1913–1991

Horses

1941

INK AND COLOURS ON PAPER

54 × 133 CM EACH

PU QUAN FAMILY COLLECTION

INSCRIBED: 1. 吾宗老松窗公精於六法尤長畫馬曾作萬駿長卷病中分賜子女
此段爲筠嘉女史所寶　今以命題淒然識質緣起
辛己清和三月　啓功拜識　八十又八

2. 以吾宗老松窗先生遺墨
病中以賜筠嘉女公子今以命題因識緣起啓功時年八十又八

SEALS: 1. 啓功私信；元伯

2. 啓功私信；元伯

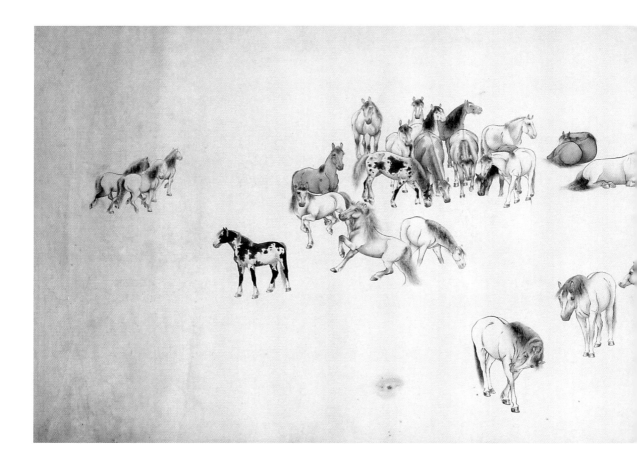

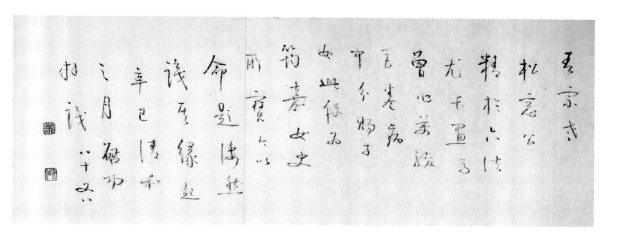

Numbers in Chinese art usually hold special meanings. For example, one means unique, two represents harmony; three means plenty; one hundred means perfection and ten thousand means infinity. One painting of which Pu Quan was particularly proud is the 'Ten Thousand Horses' (*wan ma tu*) dating to 1941 painted in Beijing.

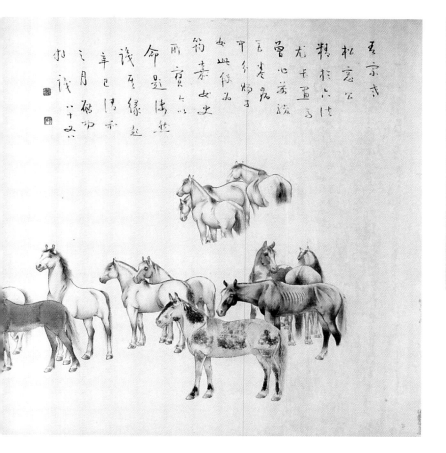

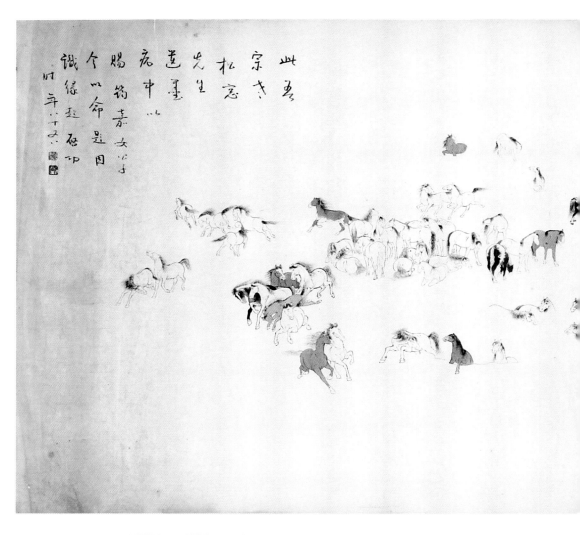

时年八十又六
识缘起启功
今以命是因
赐筠秀女弟子
庖中以
造墨
先生
松忘书
宗书
此吾

时年八十又六
识缘起启功
今以命是因
赐筠秀女弟子
庖中以
造墨
先生
松忘书
宗书
此吾

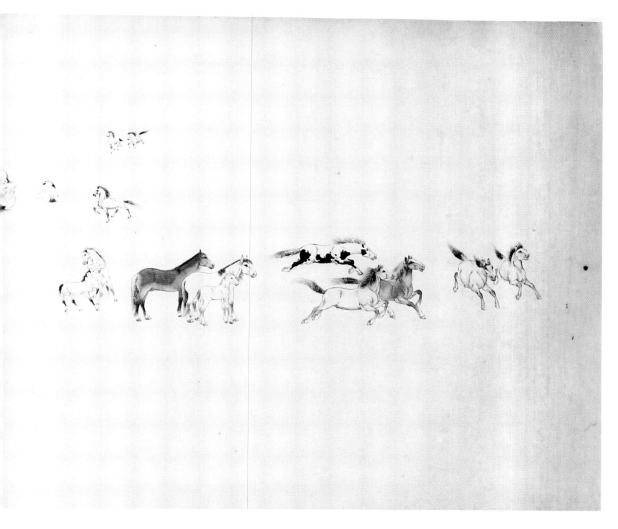

These two paintings do not carry Pu Quan's signature, however, Qi Gong's inscription records that they are parts of the 'Ten Thousand Horses (*wan ma tu*)'. Pu Quan divided this long handscroll between his children.

13

Pu Jin
1879–1966
and

Pu Quan
1913–1991
Orchids

Ink and colours on paper
45 × 85 cm
Pu Quan Family Collection
Published: Sun Zhihua, ed., *Rongbaozhai huapu 158*, Beijing
(Rongbaozhai chubanshe), 2003, p.21
Inscribed: 1. 靜能知竹趣　和可契蘭修　雪齋寫蘭
　　　　　　　2. 溥松窗補圖
Seals: 1. 南石書畫
　　　　2. 雪谿

In flower paintings, orchids have long been regarded as a metaphor for hermits. They are strongly linked to the Southern Song official Zheng Sixiao (1241–1318), who was also a famous poet and literati painter. After the decline of the Southern Song he retired from public life and refused to take official posts in the new dynasty, and most of his poems reflect his feelings about the loss of his country. Orchids and bamboo were the subjects in which he specialised. His orchid paintings are executed in ink with simple leaves and petals, and always expose the roots in the air. When asked the reason, he replied 'Losing a country is just like the orchid losing its soil, the roots float in the air.'

Pu Quan experienced imperial life, the Republic of China, the Civil War, the founding of the People's Republic of China and the Cultural Revolution. Avoiding politics he concentrated on his painting and teaching; he perhaps chose the orchid as his subject to represent his feelings as a descendant of the once powerful imperial family.

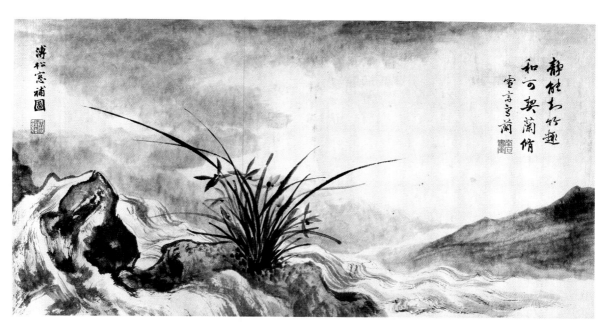

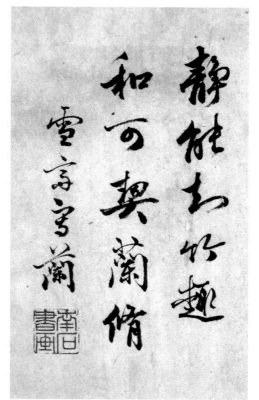

14

Pu Jin
1879–1966

and

Pu Quan
1913–1991

Yue ji rose and orchids

1950s
Ink and colours on paper
63 × 41 cm
Pu Quan Family Collection
Inscribed: 1. 雪齋寫蘭
2. 松窗畫月季花
Seals: 1. 南石書畫;
2. 雪谿

Pu Jin (1879–1966) is well known as Xue Zhai, the founder of the Pine Breeze Painting Society. The society was formed in 1925 in Beijing and consisted of Pu family members and their close friends who would meet to discuss their paintings. Every member's *hao* (nom de plume) began with the character *song* (pine), such as Pu Xinyu (Songchao), Pu Yizhai (Songlin), Qi Gong (Songhuo) and Pu Quan (Songchuang), etc.

Pu Quan had a very close relationship with his eldest brother Pu Jin and his early paintings were heavily influenced by him. They collaborated on several works. The combination of orchid (by Pu Jin) and *yue ji* rose (by Pu Quan) in this painting is very unusual, and focusses on the right hand corner. The *yue ji* is painted in outline with colour applied within and is the main subject, while the orchid is executed in ink to balance the composition.

雪齋寫蘭

雪齋寫蘭

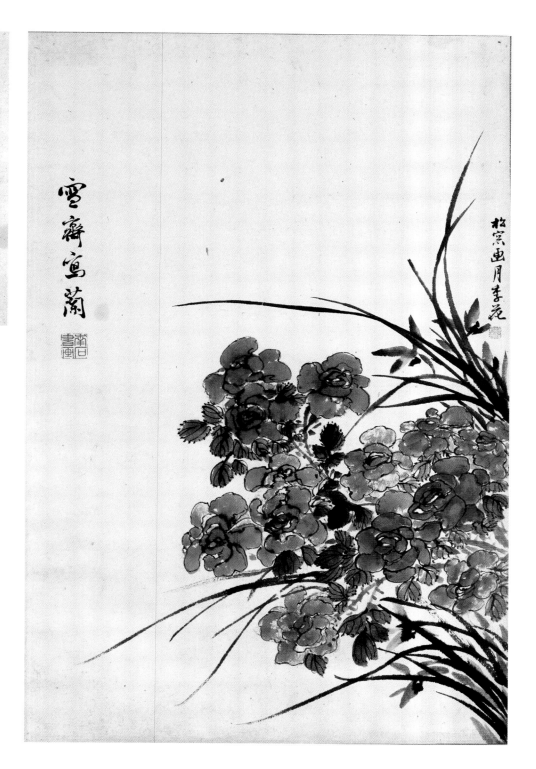

松宗畫月季花

15

Pu Quan
1913–1991
Mount Erlang

1957
Ink on paper
72 × 46 cm
Pu Quan family collection
Inscribed: 寫二郎山風景　一九五七年春　溥松窗
Seals: 溥佺長壽；松窗居士

From the mid-1950s Pu Songchuang increasingly painted landscapes rather than horses, flowers or bamboo, and he developed a much looser brushwork style.

This landscape depicts Mount Erlang in Sichuan province, which Pu had visited the previous winter as part of an artists' delegation. The trip was organised by the People's Liberation Army, which had commissioned about fifteen Beijing artists to produce a collaborative painting depicting the route of the Long March of 1934–5 in order to celebrate the thirtieth anniversary of the Army's founding as the Red Army.[1] The artists were divided into two groups, one to paint the figures and genre scenes, the other to paint the landscapes; Pu Quan was in the latter group along with Dong Shouping, Tao Yiqing, Yan Di, Li Fengbai and Li Jun. With a support group from the PLA, the delegation spent the winter of 1956–7 retracing sections of the Long March route through west China. Mount Erlang was the first place they visited on departing from Beijing, and became the subject of several later paintings by Dong Shouping (1904–1997).[2] It had also been depicted in oil sketches by the artist Dong Xiwen on a similar Long March route trip undertaken in 1955,[3] and it features in revolutionary songs; however, no accounts of the Long March record Mt. Erlang on the route, and the origins of its association with the early history of the Communist Party are unclear.

In this work, the mountain is depicted in the style and techniques of traditional landscape painting, which had become more widely practised again following Mao's declaration in May 1956 of the policy 'Let A Hundred Flowers Bloom, and A Hundred Schools of Thought Contend'.

1 The painting is in the Chinese People's Military Museum, Beijing; two sections of the scroll are reproduced in *People's China* no.15, 1 August 1957.
2 S. Vainker, 'Landscape and Revolution: Paintings by Dong Shouping (1904–97) in the Ashmolean Museum', *Apollo*, November 2002, pp.36–41.
3 Dong Xiwen, *Changzheng luxian xiesheng ji*, Beijing, 1958, pls.19–23.

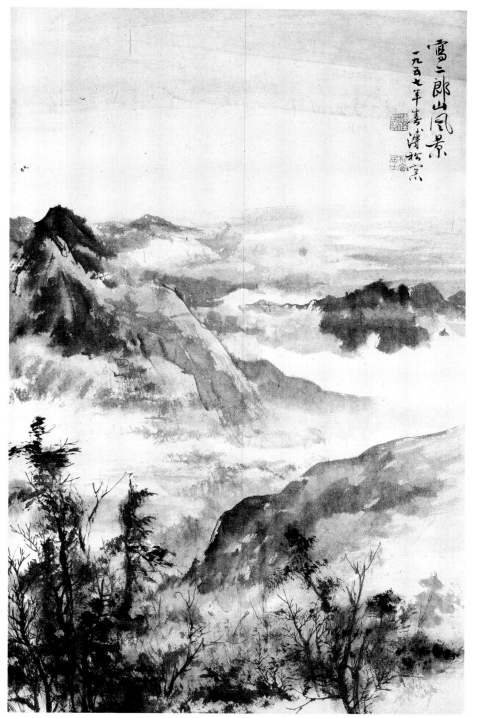

富二郎山風景
一九五七年夏 溥松窗

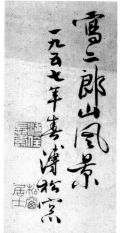

富二郎山風景
一九五七年夏 溥松窗

16

Pu Quan
1913–1991
Calligraphy, poems by Mao Zedong

1960
Ink on paper
84 × 45 cm
Pu Quan Family Collection

Inscribed: 北國風光，千里冰封，萬里雪飄。長城內外，惟余莽莽；
大河上下，頓失滔滔。山舞銀蛇，原馳臘象，欲與天公試
比高。須晴日，看紅裝素裹，分外妖嬈。江山如此多嬌，
引無數英雄竟折腰。惜秦皇漢武，略輸文采；唐宗宋祖，
稍遜風騷。一代天驕，成吉思汗，只識彎弓射大雕。俱往
矣，數風流人物，還看今朝。

我失驕楊，君失柳，楊柳輕揚直上垂霄九，問訊吳剛何所
有，吳剛捧出桂花酒。寂寞嫦娥舒廣袖，萬里長空且爲忠
魂舞，忽報人間曾伏虎，淚飛頓作傾盆雨。

一九六零年八月十日溥松窗書於首都

Seals: 溥佺長壽；雪谿

The two poems in this work are *Snow*, composed by Mao in February 1936, and *Reply to Mme. Li Shuyi*, written in May 1957.[1] Line fourteen of *Snow*, which translates 'This land with so much beauty aglow' is the title of one of the best known paintings of the first decades of the People's Republic of China. It was painted by Fu Baoshi (1904–65) and Guan Shanyue (1912–2000) for the Great Hall of the People in Tiananmen Square; it measures approximately 500 × 950 cm and depicts a panoramic landscape across mountain tops and clouds to a glowing sun, symbolizing the victory of the Communist Party under Mao.[2]

Reply to Mme. Li Shuyi was written to a friend of Mao's first wife; both Mao's wife and Mme. Li's husband had died fighting for the Communist cause and in the poem they are commemorated with references to early Chinese legends. In addition to composing his own verses, Mao Zedong often wrote out well-known works by China's early poets, particularly those of the Tang dynasty (AD 618–906).[3]

1 Both are translated in Wong Man, *Poems by Mao Tse-tung*, Hong Kong (Eastern Horizon Press), 1966.
2 Laing, E. J., *The Winking Owl: Art in the People's Republic of China*, Berkeley and Los Angeles, 1988, p. 36 and fig. 38; also Andrews, J. and K. Shen, *A Century in Crisis: Modernity and Tradition in the Art of Twentieth-Century China*, New York, 1988, pp. 230–1.
3 *Mao Zhuxi shici moji*, 2 vols., Beijing, 1973 and 1978.

北国风光，千里冰封，万里雪飘。望长城内外，惟余莽莽；大河上下，顿失滔滔。山舞银蛇，原驰蜡象，欲与天公试比高。须晴日，看红装素裹，分外妖娆。

江山如此多娇，引无数英雄竞折腰。惜秦皇汉武，略输文采；唐宗宋祖，稍逊风骚。一代天骄，成吉思汗，只识弯弓射大雕。俱往矣，数风流人物，还看今朝。

我失骄杨君失柳，杨柳轻飏直上重霄九。问讯吴刚何所有，吴刚捧出桂花酒。寂寞嫦娥舒广袖，万里长空且为忠魂舞。忽报人间曾伏虎，泪飞顿作倾盆雨。

一九六零年八月十日

溥松窗书于首都

17

Pu Quan

1913–1991

Clearing after Spring rain

1960
Ink and colour on paper
65 × 95 cm
Pu Quan Family Collection
Published: Sun Zhihua, ed., *Rongbaozhai huapu* 158, Beijing
(Rongbaozhai chubanshe), 2003, p.13
Inscribed: 春雨初晴　一九六零年溥松窗寫於首都
Seals: 溥佺長壽；松窗

The title of this painting is a traditional title sometimes used on landscapes of the Song dynasty and later. Here Pu Quan has used it for a depiction of the Great Wall, which was itself a theme in traditional literature though much less so in painting. In this work its representation is associated with the revival of nationalism in art during the late 1950s, in terms of both techniques and subject matter. The panorama across mountain tops and the wall itself reflect the grandeur of both China's landscape and historical achievements, in a composition that possibly owes something to the work by Pu's colleagues Fu Baoshi and Guan Shanyue completed for the Great Hall of the People the previous year (discussed in no. 16).

The inscription records that this painting was composed in 1960 in Beijing.

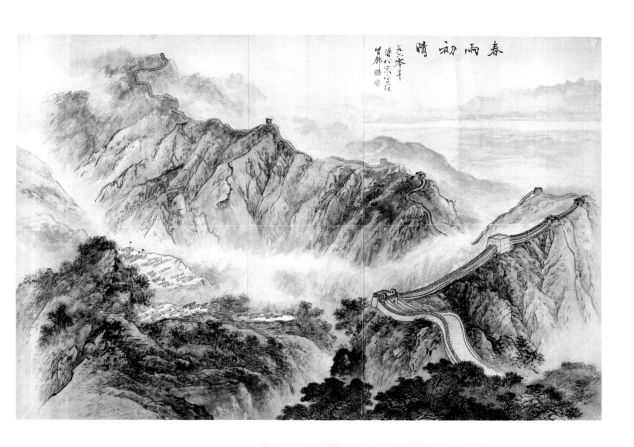

春雨初晴

二六零年
溥松窗寫於
首都

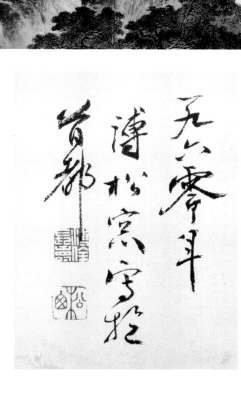

18

PU QUAN
1913–1991
Bamboo and ducks

1961
INK AND COLOURS ON PAPER
128 × 67 CM
PU QUAN FAMILY COLLECTION
PUBLISHED: SUN ZHIHUA, ED., *Rongbaozhai huapu* 158, BEIJING
(RONGBAOZHAI CHUBANSHE), 2003, P. 33
INSCRIBED: 一九六一年七月十五日溥松窗寫於首都
SEALS: 溥佺長壽；雪谿

The bamboo in this painting is elegantly depicted with upright leaves,
suggesting they are in sunshine. Two ducks flying in s-shaped formation lead
the viewer's attention to the lower left corner. The whole painting is executed
in ink and the composition is well-balanced with an inscription at the top
right corner which dates the painting to 15th July 1961 in the capital Beijing.
This is one of the finest examples of Pu Quan's bamboo painting.

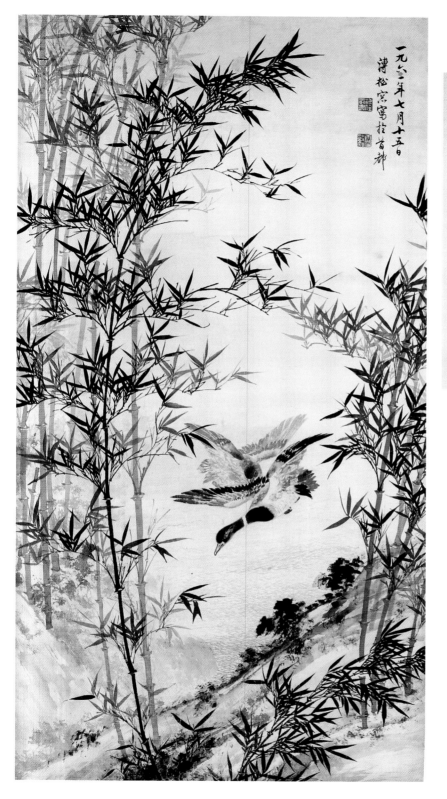

一九六二年七月十五日
溥松窗寫於首都

一九六二年七月十五日
溥松窗寫於首都

19

Pu Quan
1913–1991
Luding

Ink and colour on paper
48 × 87 cm
Pu Quan Family Collection
Published: Sun Zhihua, ed., *Rongbaozhai huapu* 158, Beijing
(Rongbaozhai chubanshe), 2003, p.4
Inscribed: 瀘定　溥松窗畫
Seal: 溥佺長壽；松窗

Luding is the name of a town on the east bank of the Dadu River in Sichuan, and the site of one of the most famous episodes of the Long March. The Red Army stormed Luding, a Nationalist stronghold, in May 1935 by making an attack from the west bank across the chain bridge above the notoriously turbulent Dadu. The confrontation gained particular significance for the Red Army as the river had been the eventual point of defeat for a famous general of the Taiping army in the mid-nineteenth century; General Shi Dagai too had previously fought in Jiangxi province, and in a pamphlet drop on the area days before the 1935 attack, the Nationalists had likened Mao to him.[1]

Pu Quan visited Luding during the winter of 1956–7 while retracing the Long March route with a delegation of artists and representatives of the People's Liberation Army, and was photographed on the famous bridge alongside Dong Shouping, Tao Yiqing and other painters.[2] Though this painting is not dated, it is similar to Pu's works of the early 1960s in both its subject matter and palette (see also no.25).

1 Sun Chi-hsien, 'The forced crossing of the Tatu River' in *The Long March: Eyewitness Accounts*, Beijing, 1963, p. 83.
2 Reproduced in Li Yu and Zhao Baoqin (eds), *Dong Shouping xiansheng jinian wenji*, Beijing, 2000.

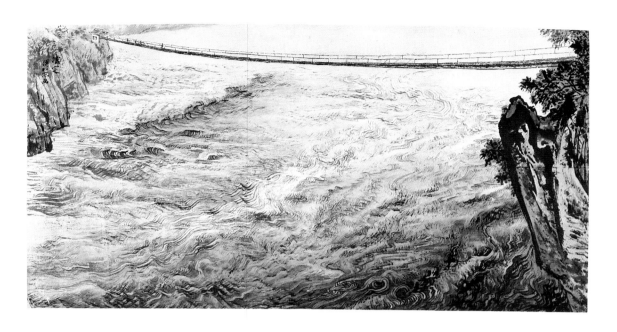

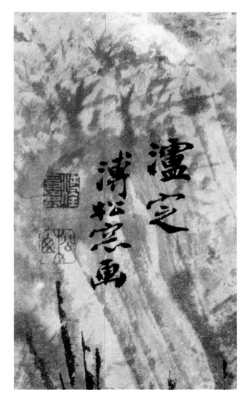

20

Pu Quan
1913–1991
The Wu River natural barrier

1962
Ink and colour on paper
56 × 115 cm
Pu Quan Family Collection
Inscribed: 烏江天險　一九六二年五月　溥松窗
Seals: 溥佺長壽; 松窗

The fast-flowing Wu River, with its precipitous banks, forms a natural barrier across Guizhou province in southwest China. The crossing of the Wu River in early January 1935 was a major incident on the Long March; after three attempts under fire from the Nationalists the Red Army finally crossed it and were able to proceed north.[1]

In this painting, dated May 1962, Pu Quan has depicted the river as a formidable natural feature in dramatic lighting. It was not until the trip he undertook retracing the route of the Long March in the winter of 1956–7 (see cat. no.15) that he began to tackle landscape in a more vigorous ink painting style, which he developed throughout the early 1960s, and he is reputed to have greatly preferred this painting method.

1 Liu Yalou, 'The Fight for the Wukiang Crossing', *The Long March: Eyewitness Accounts*, Beijing, 1963, pp. 11–21.

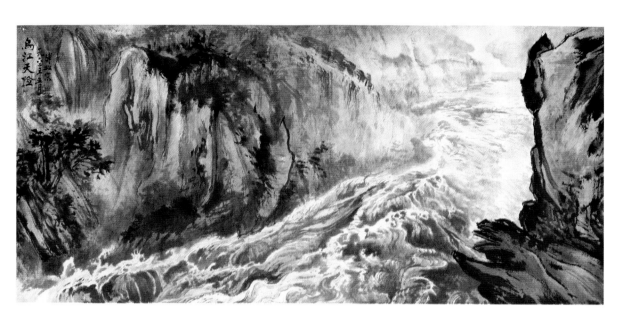

21

Pu Quan
1913–1991
Wu River

1962
Ink and colour on paper
56 × 95 cm
Pu Quan Family Collection
Inscribed: 穩渡烏江險　開航第一艘　一九六二年溥松窗
Seals: 溥佺長壽; 松窗

This landscape, like cat. no. 20, was painted in 1962 and depicts the Wu River
in Guizhou province. Pu's inscription, which has unusually been written on
an area of mountain rather than at the edge of the composition, reads:
'safely crossing the perilous Wu River, the first sailing after navigation
re-opened'. This, together with the red flag on the peak in the foreground,
alludes to the successful crossing of the Wu by the Red Army in January 1935
during the Long March. The Communists then went on to take Zunyi in
northern Guizhou; they stayed for twelve days there, and held a large
conference at which Mao Zedong was installed as leader of the Central
Committee.

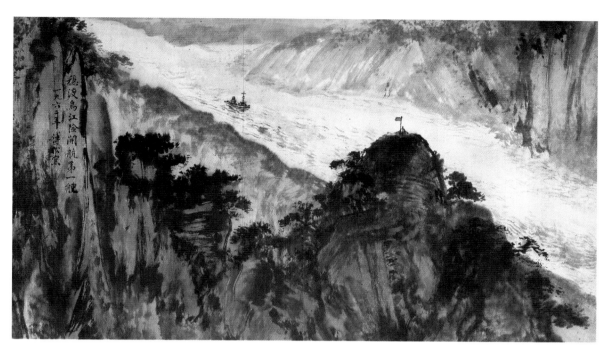

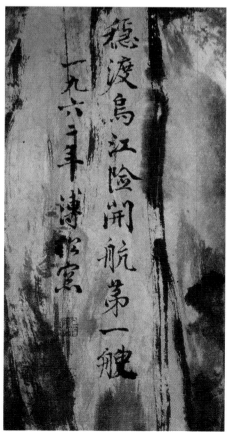

稳渡乌江险开航第一艇

一九六二年 溥松窗

22

Pu Quan
1913–1991
Guanting Reservoir – morning

1963
Ink and colour on paper
64 × 126 cm
Pu Quan Family Collection
Inscribed: 官廳水庫之晨
　　　　　一九六三年溥松窗
Seals: 溥佺長壽；松窗

The Guanting Reservoir was constructed between 1951 and 1954 in order to bring under permanent control the loessic waters of the Yongding River, known as the 'small Yellow River'; it is situated in Hebei province and is still a major reservoir for Beijing. River control is associated with the achievement of several early emperors and legendary figures in Chinese history, and the depiction of a successful engineering project as part of a landscape in traditional style is very much in keeping with ink painting of the period between 1961 and 1964. In this work, as in his painting of the Great Wall (no. 17) three years earlier, Pu Quan has retained the distinctive palette of his early landscapes (see no. 3). The brushwork however is looser, due to the transformation in his painting style and also, in part, to the use of paper rather than silk as a support. Paper is more responsive to brush and ink than silk, which is a less absorbent medium and requires sizing before it is used.

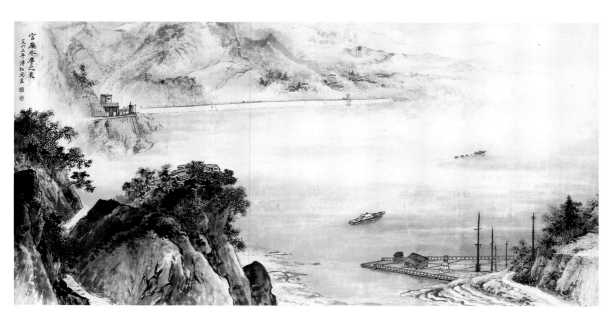

23

Pu Quan
1913–1991
Viewing the pine trees through clouds in the mist

1964
Ink and colour on paper
180 × 64 cm
Pu Quan Family Collection
Inscribed: 暮色蒼茫看勁松　亂雲飛渡仍從容　天生一個仙人洞
無限風光在險峯
一九六四年元月溥松窗畫

Seals: 溥佺長壽；雪谿

This mountain landscape, painted in the first month of 1964, is inscribed with a poem composed by Mao Zedong on 9 September 1961. The poem was written on a photograph, taken by his comrade Li Jin, of Xianren Dong (Immortals' Cave) on Mount Lu in Jiangxi province. Mt. Lu is a famous beauty spot celebrated both in literature – notably by the Song dynasty poet Su Dongpo – and in art throughout China's history. Xianren Dong on its western cliff has long been associated with Daoist monks and alchemy while the People's Hall on the south side of Mt. Lu was the venue for two important meetings of the Central Committee of the Communist Party in the late 1950s.

Mao's poem is written in four lines of seven characters, in accordance with the *qilu* form developed in the Tang dynasty, and translates:

> In the blue-green hues of dusk I see the rough pines
> Still peaceful beneath the wildly rushing clouds.
> Heaven made a cave for the immortals
> Endlessly beautiful amongst the dangerous peaks.

The colours Pu Quan has used for this landscape are more vivid than his usual palette. It was painted in a period when red was often used for its political connotations, and it is perhaps possible that the glow in this work alludes to Mao, whose burgeoning personality cult at this period identified him with the sun.

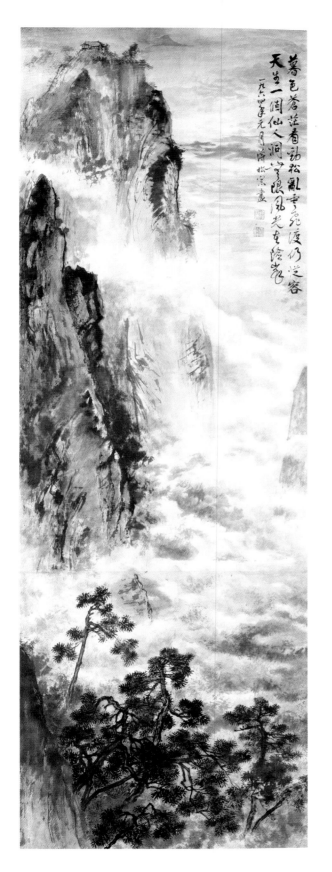

暮色蒼茫看勁松亂雲飛渡仍従容
天生一個仙人洞無限風光在険峯
一九六四年元月蕭松宏畫

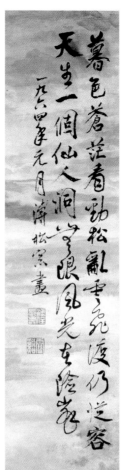

暮色蒼茫看勁松亂雲飛渡仍従容
天生一個仙人洞無限風光在険峯
一九六四年元月蕭松宏畫

24

Pu Quan
1913–1991

With calligraphy by

Pu Jie
1907–94

Landscape

1965
Ink and colour on paper; ink on paper
61 × 63 cm (painting); 31 × 63 cm (calligraphy)
Inscribed: 1. 一九六五年溥松窗畫
2. 雙管韻韻融　雲巘巇千帆　澄漾嶺盤旋
歲次庚午清秋題
松窗兄山水畫軸允嘆觀止　韻字衍
溥傑
Seals: 1. 溥佺長壽；松窗
2. 愛新覺羅；溥傑長壽

This composition, of squareish format with a view across mountaintops and down to a river gorge, was used by several artists in the early 1960s, including Fu Baoshi and Li Keran. It probably depicts the Yangzi in Sichuan province. The traditional landscape colours of buff and light blue have been used extensively as washes, to colour rather than highlight the ink composition.

The calligraphy by Pu Jie mentions the steep cliffs, the clouds and the boats.

雙管齊韻
顧瓶密密
鼉雲躍千
帆澄漾
嶺巖逸
松窗兄山水
畫軸兄嘆
觀心龡孚行
溥傑

歲次庚午
清龍頭

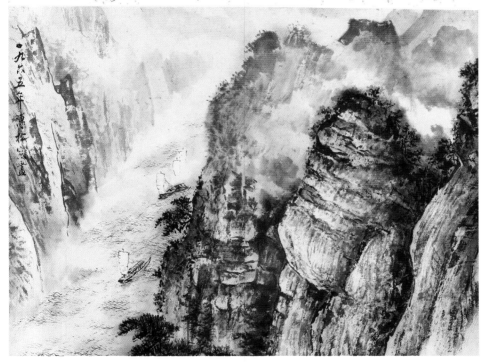

一九六五年溥松窗畫

溥傑

63

25

Pu Quan

1913–1991

The cold iron chains of Dadu bridge

1973
Ink on paper
39 × 112 cm
Pu Quan Family Collection
Published: Sun Zhihua, ed., *Rongbaozhai huapu 158*, Beijing
(Rongbaozhai chubanshe), 2003, p.9
Inscribed: 大渡橋橫鐵索寒
　　　　　一九七三年七月一日爲崇嘉女兒畫　松窗

Seals: 松窗

Pu Quan visited Luding bridge across the Dadu River in Sichuan during the winter of 1956–7 as part of the artists' group travelling the route of the Long March under the auspices of the People's Liberation Army (see no. 15). The bridge had a span of some two hundred metres and was constructed in the eighteenth century using thirteen iron chains, with nine providing a support for wooden cross-planks and two at each side serving as handrails. The storming of Luding bridge by a vanguard of twenty-two soldiers enabled the Red Army to cross the turbulent Dadu River into Nationalist-held territory; it took place in the spring of 1935, and became one of the most celebrated incidents of the Long March. At the time of the assault the bridge was cold from melting snows, and the wooden boards had mostly been removed by the Nationalists.

The title of the painting quotes the sixth line of Mao Zedong's eight-line poem *The Long March* written in October 1935 (see catalogue no. 26) and also records that the work was painted in July 1973 for the artist's fourth daughter, Chongjia. Landscapes depicting places on the Long March were painted by Pu Quan and several of his contemporaries but the only pictures to survive from the actual journey of 1934–5 are the sketches of the general Huang Shen; though his works are brief and cartoon-like, his composition of the Luding bridge across the Dadu has been borrowed here by Pu Quan, who has painted it from the same viewpoint and at river level.

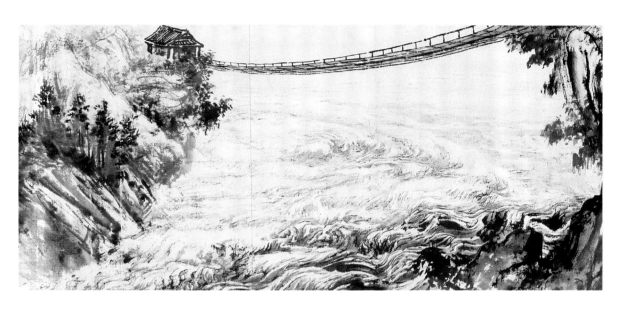

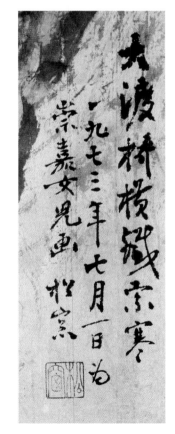

大渡橋横鐵索寒

一九七三年七月一日為

崇嘉女兒畫 柏宗

26

PU QUAN
1913–1991
Calligraphy, The Long March

1975
INK ON PAPER
41 × 103 CM
PU QUAN FAMILY COLLECTION
INSCRIBED: 紅軍不怕遠征難　萬山千山只等閑　五嶺逶迤騰細浪
烏蒙磅礡走泥丸　金沙水拍雲崖暖　大渡橋橫鐵索寒
更喜岷山千里雪　三軍過後盡開顏
一九七五年十月十九日紀念長征勝利四十週年　松窗

SEAL: 雪谿

The text of the calligraphy is Mao Zedong's poem *The Long March*, written in October 1935. Composed in the seven-character line form developed in the Tang (618–906) dynasty, it records in eight lines the principal obstacles and triumphs of the route undertaken by the Red Army and its followers between October 1934 and the same month the following year:

> *The Red Army feared not the Long March trials*
> *Ten thousand crags and torrents but easy miles,*
> *The Five Ridges outspread like softening ripples,*
> *The Wumeng Range contoured as bouncing mud pills.*
> *Let the waves of Golden Sands beat on precipices warm,*
> *And the bridge at Dadu confront it with iron chains cold,*
> *What joy over Minshan's thousand li of snow:*
> *The Army thence becomes all smiles!* [1]

The Long March covered some eight thousand miles, and no more than a quarter of those who set out completed it. It was undertaken in order to escape from and then rout Chiang Kai-shek's Guomindang Nationalist army, and had the result of consolidating Mao's leadership of the Communist Party. The style of calligraphy Pu Quan has used in this work is a departure from his own quite regular style and recalls the thin, cursive character of Mao Zedong's writing.

1 Translated by Wong Man in *Poems by Mao Tse-Tung*, Hong Kong (Eastern Horizon Press), 1966, p. 32. Wong Man's annotations on p. 78 of the same book note that the 'bouncing mud pills' are taken from the Han (221 BC–AD 220) dynasty biography of Guai Feng.

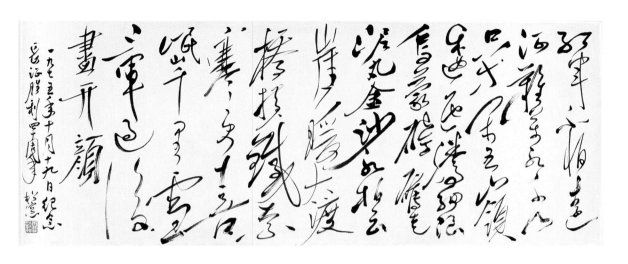

27

Pu Quan
1913–1991
Morning sunlight at Ciping

1977
Ink and colour on paper
81 × 150 cm
Pu Quan Family Collection
Published: Sun Zhihua, ed., *Rongbaozhai huapu* 158, Beijing
(Rongbaozhai chubanshe), 2003, p.26
Inscribed: 茨坪朝暉　一九七七年松窗
Seal: 雪谿; 松窗

Ciping, also known as Jinggangshan, is in southern Jiangxi province and was the location of one of the Communist Party's rural bases in the early 1930s. In October 1934, surrounded there by Nationalist soldiers, the Communists fought their way westwards through the blockade under the leadership of Zhu De and Mao Zedong, and began the Long March. There are several monuments to the revolution in Ciping and one of these, the Martyr's Tomb, is depicted at the left of this painting. A comparable view of Ciping was painted in about 1964 by Fu Baoshi (1904–65).[1]

1 Nanjing Museum, ed., *Artist's Vision, Poet's Passion: The Paintings of Fu Baoshi*, Beijing (Morning Glory Publishers), 1988, no.69.

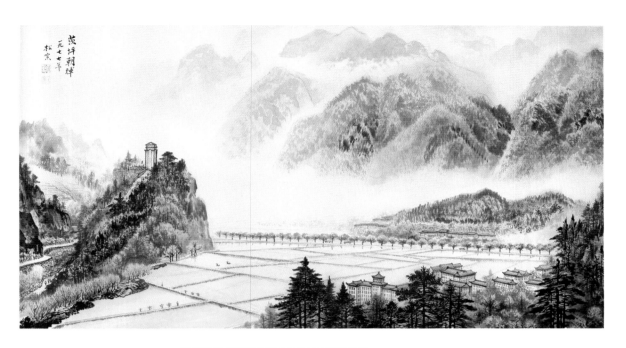

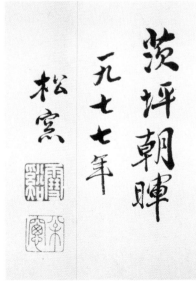

茨坪朝暉
一九七七年
松崑

28

PU QUAN
1913–1991
Landscape

1981
INK ON PAPER
135 × 67 CM
PU QUAN FAMILY COLLECTION
INSCRIBED: 兩岸猿聲啼不住　輕舟已過萬重山
一九八一年二月樹棠賢婿、筠嘉女兒清品
溥松窗

SEALS: 雪谿; 松窗

This landscape is comparable in composition to that painted twenty-seven years previously (see cat. no. 24), though the format is longer and narrower. The main part of the inscription cites a couplet by the Tang dynasty poet Li Bai (701–762) and translates, 'On both banks the sound of the gibbons' screams is ceaseless; the light boats have already passed countless mountains'. It ends with the date and a dedication to the artist's daughter Yun Jia and his son-in-law Shutang.

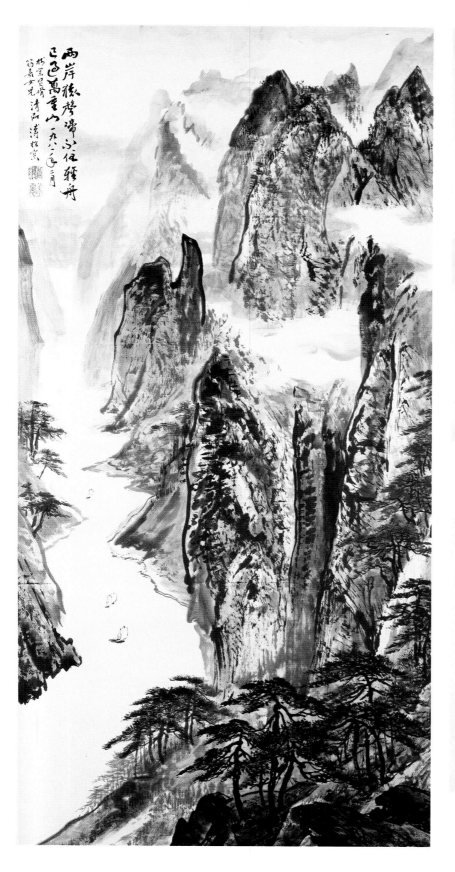

両岸猿聲啼不住
己色萬重山 一九八〇年二月

柏棠賢婿
筠嘉女兒
清品 溥松窗

29

PU QUAN
1913–1991
Boating on the stream

c.1984
INK AND COLOUR ON PAPER
133 × 67 CM
INSCRIBED: 溪停泛舟　溥松窗
SEALS: 雪谿；松窗

Pu Quan's later landscapes use the loose ink style he developed in the late
1950s; the very traditional structures of their compositions however recall his
earliest works, and this painting exemplifies both characteristics. Pu is said to
have preferred this looser style, particularly as he grew older and his eyesight
began to fail.

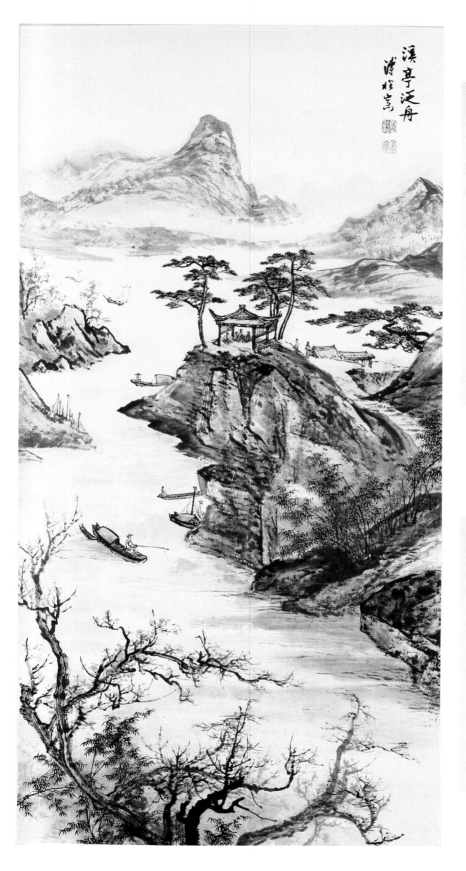

溪亭泛舟
溥柈畫

30

Pu Quan
1913–1991
and
Pu Zuo
1918–2001

Yue ji, bamboo and rock

1986
Ink and colours on silk
84 × 40 cm
Pu Quan Family Collection
Inscribed: 丙寅年秋八月溥松窗溥佐合筆
Seals: 1. 愛新覺羅溥佺一字松窗書畫之印
 2. 愛新覺羅溥佐字庸齋長壽印

Pu Zuo was Pu Quan's younger brother. He became a member of the Pine Breeze Painting Society in 1937 and had a joint exhibition with Pu Xinyu in Tianjin in 1944.

In classical flower-and-bird painting, the depiction of *yue ji* roses in a vase (*ping*), connotes protection from harm (*yue yue ping an*). However, bamboo and rocks are also used in the same composition with *yue ji* to represent this meaning. Both *yue ji* roses and bamboo in this painting are executed in free style. A few new bamboo shoots at the lower left are arranged to balance the heavy rock in the main section of the painting. This painting was executed towards the end of the artists' lives and having lived through periods of profound change, probably reflects their desire for a peaceful life.

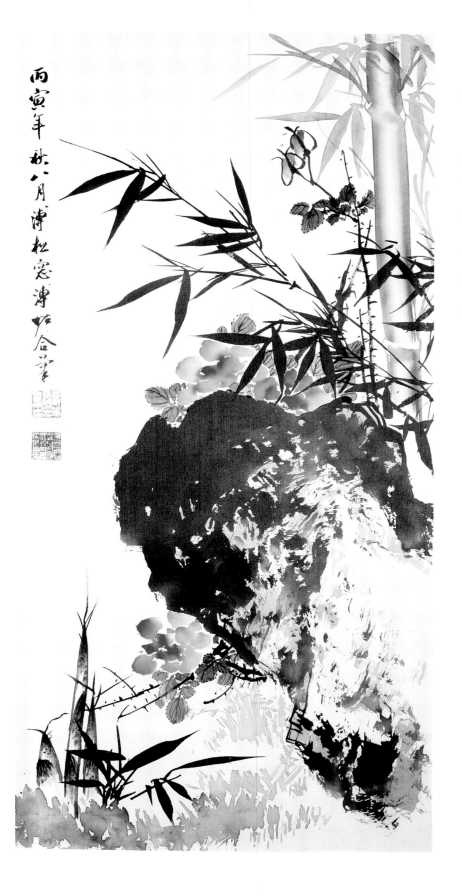

丙寅年秋八月溥松窗溥佐合筆

31

Pu Quan

1913–1991

Horses

c.1986
Ink and colours on silk
83 × 47 cm
Pu Quan Family Collection
Inscribed: 愛新覺羅溥松窗
Seals: 松窗; 溥佺長壽

In the period before the Tang dynasty, horses were almost always depicted with human figures, in hunting scenes and processions. However from the Tang dynasty onwards, the horse became a central and independent subject in painting. The training, pasturing, tending, and grooming of horses are common subjects in horse painting. In this work Pu Quan has tried to depict horses within a landscape, which was a break from tradition and reveals the influence of the well-known horse painter Giuseppe Castiglione (1688–1766) (see no. 11). He creates the space by placing a rock in the front, three horses in the middle and the landscape behind; in addition, silk is a good material for creating such a three-dimensional effect.

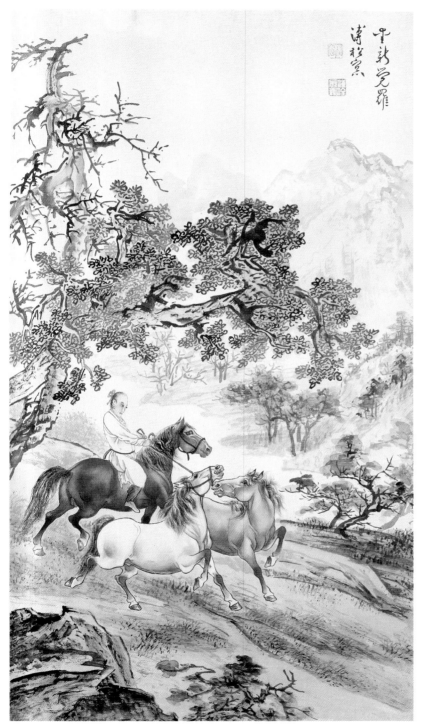

32

Pu Quan

1913–1991

Birds in a green landscape

1980s
Ink and colour on paper
43 × 65 cm
Pu Quan Family Collection
Published: Sun Zhihua, ed., *Rongbaozhai huapu* 158, Beijing
(Rongbaozhai chubanshe) 2003, p.33
Signed: 溥松窗畫
Seals: 溥佺長壽; 松窗

This painting is unusual in its bold use of varying tones of a single, strong
colour, and also in its lack of a clearly structured composition. It could be
read as an exercise in depicting clouds and water, along the lines of some
types of Ming painting in which dragons are shown against a swirling
ground.

33

PU QUAN
1913–1991
Landscape with waterfall

1980s
INK AND COLOUR ON PAPER
68 × 68 CM
PU QUAN FAMILY COLLECTION
PUBLISHED: SUN ZHIHUA, ED., *Rongbaozhai huapu* 158, BEIJING
(RONGBAOZHAI CHUBANSHE) 2003, NO.24
SIGNED: 愛新覺羅溥松窗
SEALS: 松窗; 溥佺長壽

The square format of this landscape is typical of later twentieth-century traditional ink painting, and the depiction of the water is typical of Pu Quan's river paintings of the early 1960s (see cat. nos. 19–21, 24). The subject itself however – of a group of scholars viewing a waterfall – has a much longer history and was well-known in the seventeenth century. It is notable that in his late paintings Pu Quan returned to traditional composition, and again favoured the palette he had used for landscapes in the early part of his career (compare cat. no. 3).

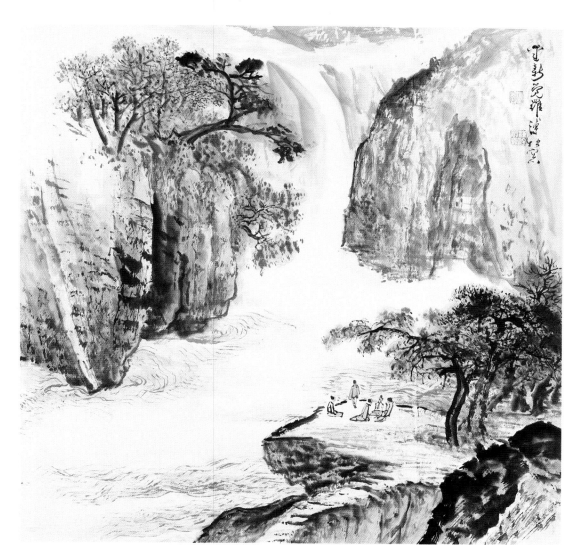

34

PU QUAN
1913–1991
Landscape

1980s
INK ON PAPER
138 × 67 CM
PU QUAN FAMILY COLLECTION
PUBLISHED: SUN ZHIHUA, ED., *Rongbaozhai huapu* 158, BEIJING
(RONGBAOZHAI CHUBANSHE), 2003, P.37
INSCRIBED: 波濤夜驚風雨驟至
　　　　　愛新覺羅溥松窗

SEALS: 松窗七十后所作；愛新覺羅溥佺書畫印信長壽

The inscription on this landscape refers to billowing waves and the sudden
arrival of wind and rain. Its vigorous style recalls Pu Quan's turbulent rivers
of twenty years previously (see nos. 20, 21) but the brushwork is typical of
his later works.

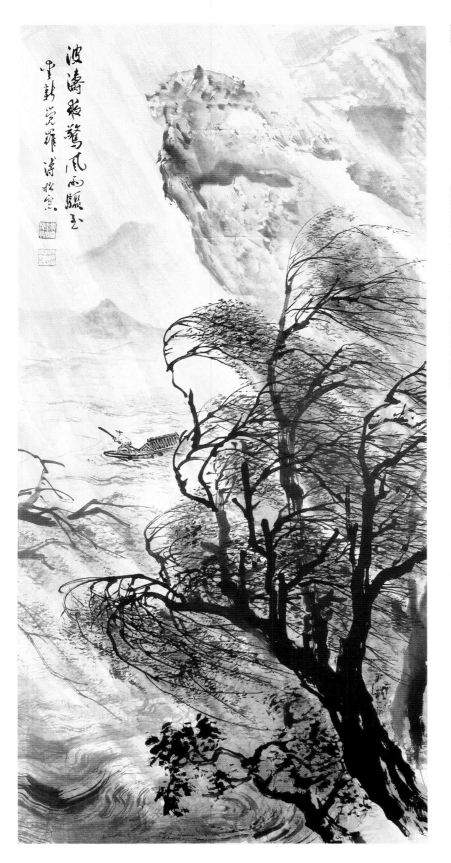

波濤觀驚風雨驟至
重新覺羅溥松窗

35

PU QUAN
1913–1991
and
PU JIE
1907–1994
Bamboo

1990
INK AND COLOURS ON PAPER
133 × 45 CM
PU QUAN FAMILY COLLECTION
PUBLISHED: SUN ZHIHUA, ED., *Rongbaozhai huapu* 158, BEIJING
(RONGBAOZHAI CHUBANSHE), 2003, P.14
INSCRIBED: 1. 愛新覺羅溥松窗
 2. 風靜一簾篩月影　心虛三昧聽秋聲
 庚午新秋溥傑
SEALS: 1. 愛新覺羅溥松窗書畫之印；松窗七十后所作
 2. 愛新覺羅；溥傑長壽

Bamboo and orchid, together with plum flowers and chrysanthemums, are regarded as the Four Gentlemen in traditional Chinese flower painting and were typical literati subjects. This bamboo was painted by Pu Quan with calligraphy by his cousin Pu Jie and dates to 1990, a year before Pu Quan's death and four years before Pu Jie died. Pu Jie is well known as the brother of Pu Yi, the last emperor, and became a politician in his latter years. Pu Quan only used his Manchu name in inscriptions on paintings in the 1980s, perhaps revealing a greater confidence in declaring his imperial roots. In addition, his signature is more flowing in this period, unlike the *kaishu* (regular script) signature which he used before that time.

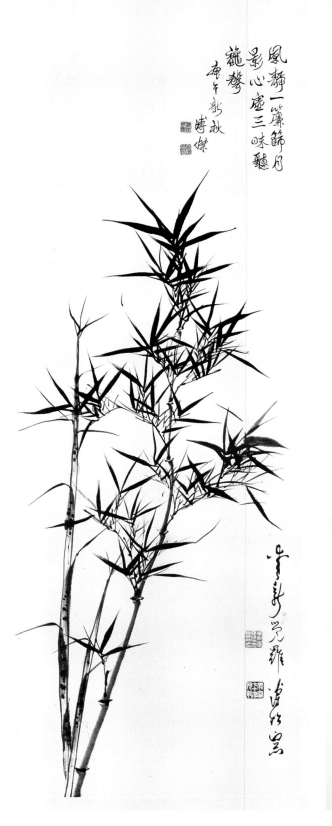

風靜一簾篩月
影心虛三昧聽
籠聲
庚午新秋
溥傑

風靜一簾篩月
影心虛三昧聽
籠聲
庚午新秋
溥傑

溥傑

85

36

Pu Quan
1913–1991
A set of ten teaching sketches

1940s
Ink and colours on paper
30 × 46.5 cm (average)
Pu Quan Family Collection
Published: Wang Yu, ed., *Shanshui huafa quantu*,
(Renmin meishu chubanshe), 1990, pp. 1, 8, 11, 13, 20, 22, 35, 36, 40
Seals: each sketch has a seal 松窗

Pu Quan devoted himself to teaching, both at academic institutions and through private lessons. He began teaching at Fu Ren Catholic University when he was 23 (1936) and became a professor at the National Beijing Art School when he was 30 (1943). He produced many sketches for students to practice and was kind, generous and patient to his pupils. His foreign students included Katy Talati and the German diplomat Fritz van Briessen, both of whom studied with him privately and subsequently kept some of his teaching sketches. Fritz van Briessen published *The Way of the Brush: Painting Techniques of China and Japan* in 1962 based on Pu Quan's painting sketches.

Pu Quan had an excellent knowledge of Chinese art history and was well-trained in traditional painting skills. He knew how to teach step by step, as is evidenced by the systematic teaching sketches that he prepared. He divided the major elements of Chinese painting, such as trees, rocks, waterfalls and clouds into different chapters. The delicate line drawings of different waves (fig. a) and clouds (fig. b) are good examples of his skilful techniques.

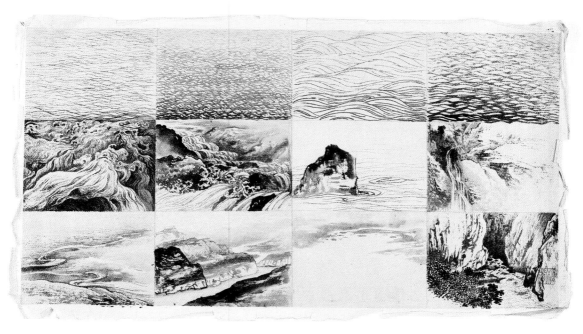

a

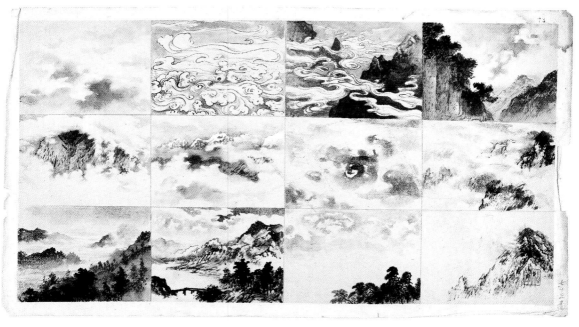

b

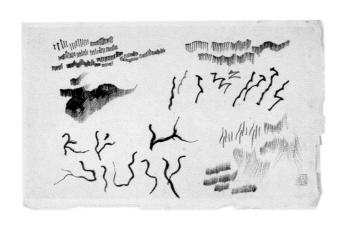

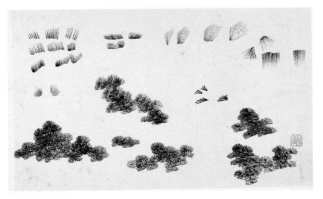

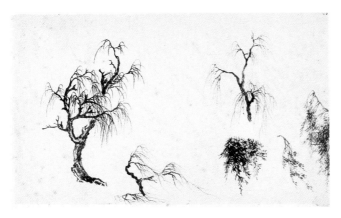

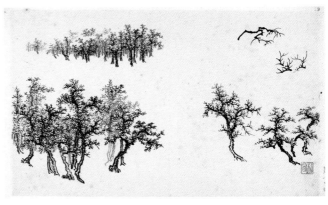

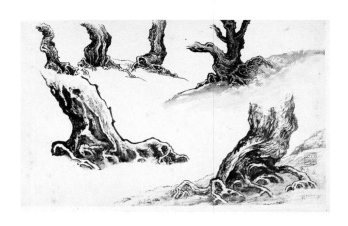

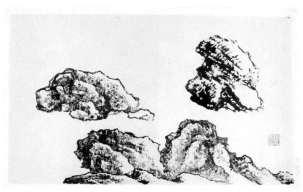

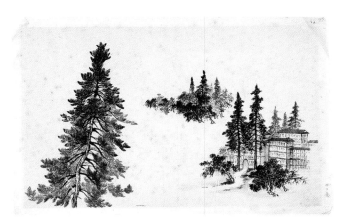

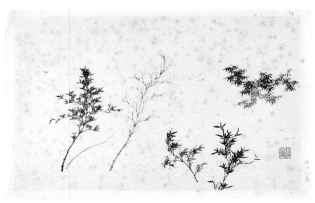

37

ZHOU SICONG

1939–1996

Portrait of Pu Quan

1973
INK AND COLOURS ON PAPER
47 × 34 CM
PU QUAN FAMILY COLLECTION
INSCRIBED: 七三年冬　思聰畫

Zhou Sicong was a female painter who specialised in figure painting and genre scenes. She was the vice president of the Beijing branch of the Chinese Artists Association and a committee member of Beijing Political Bureau in 1980. This portrait of Pu Quan was painted in winter 1973 when he was 60 and was possibly intended to mark his reaching that important birthday. This portrait differs from traditional Chinese ancestral portraits in several ways: first, it does not depict the whole body; second, he is depicted in a slight profile instead of face on; third, the artist has emphasized the play of light and muscles on Pu Quan's face, while the clothes are painted with simple brushwork, suggesting that the artist was trained in western watercolour techniques.

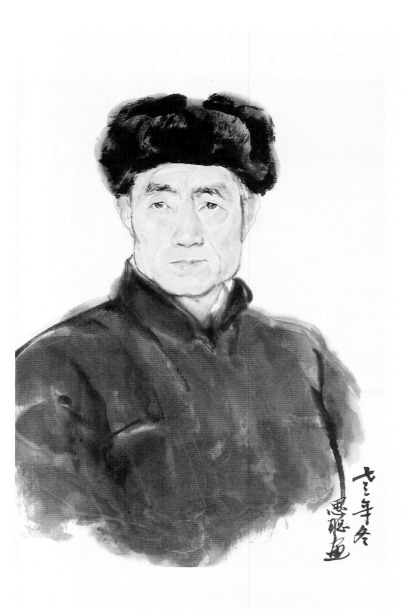

38

Yun Jia
1938–

Chong Jia
1941–

and

Wen Jia
1943–

Ten thousand streams squabble over trifles

2003
Ink and colours on paper
46 × 110 cm
Pu Quan Family Collection
Inscription: 萬壑爭流　愛新覺羅筠嘉、崇嘉、文嘉合作
Seals: 1．愛新覺羅筠嘉；2．愛新覺羅崇嘉；3．愛新覺羅文嘉；4．一硯犁華雨

This painting is a collaborative work by Aixin Jueluo Yun Jia, Chong Jia and
Wen Jia, Pu Quan's three daughters, in 2003 to commemorate their father's
painting exhibition in the Ashmolean Museum, Oxford in 2004. The title
'Ten thousand streams squabble over trifles' also implies their artistic
inheritance from their father.

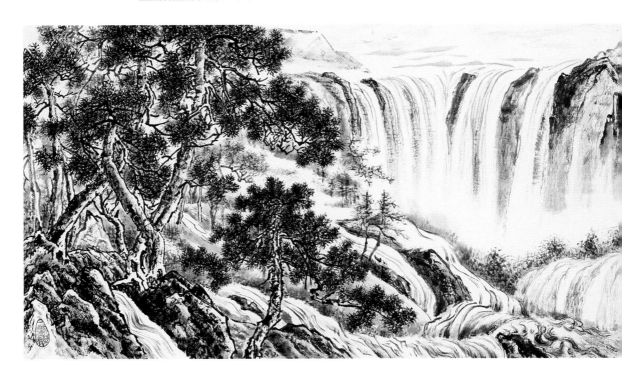

The three daughters studied landscape from their father from early childhood although Pu Quan wanted them to learn science, since all his life he struggled for a living as a painter. The close relationship between daughters and father is often seen in the inscriptions on paintings Pu Quan dedicated to them. This painting has three personal seals next to the signatures of Yun Jia, Chong Jia and Wen Jia on the right, and a pastime seal on the left to balance the composition.

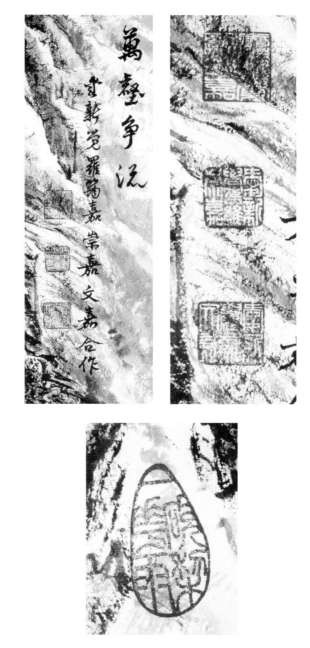

CHRONOLOGY

1913	Born in Beijing
1922	Began studying painting with his father Zhai Ying
1925	Joined the 'Pine Breeze Painting Society'
1933	Married Ya Shuhe
1936	Joined and exhibited with the Chinese Painting Research Society
	Began teaching in Fu Ren Catholic University
	First daughter Aixin Yu Jia born
1938	Second daughter Aixin Yun Jia born
1940	Third daughter Aixin Long Jia born
1941	*Ten Thousand Horses*
1942	Joint exhibition with his students
	Fourth daughter Aixin Chong Jia born
1943	Appointed Professor at National Art School, Beijing
	Fifth daughter Aixin Wen Jia born
1945	Titular Secretary to Lieutenant Colonel in the 11th Headquarters during the war
1946	*Rich and wonderful streams and mountains* (cat. no. 4)
1948	Painted a white peony as a birthday present for Katy Talati (cat. no. 7)
	Camellia and rock on gold paper (cat. no. 5)
1949	Joint exhibition with Qi Gong at the Central Park, Beijing
	Joined Beijing New Chinese Painting Research Society
1950	Group exhibition with Pu brothers organised by Rongbaozhai, Beijing
1952	First son Yu Ting born
1953	Secretary of Beijing Chinese Painting Research Society
1955	*One hundred horses*
1956	Joins Chinese Artists Association
	Sketches scenes along the Long March route
1957	*Mount Erlang* (cat. no. 15); *Long March* handscroll
1958	Beijing Chinese Painting Research Society becomes the Beijing Art Academy
1959	*Wind bamboo*, *Old pine*, *Taiwanese scenes*, *Great Wall* and other works for the Beijing People's Hall

1960	Calligraphy of Mao's poems (cat. no. 16); *Clearing after Spring Rain* (cat. no. 17)
1961	*Bamboo and ducks* (cat.no. 18)
1962	*Wu River* (cat. no. 21); *The Wu River Natural Barrier* (cat. no. 20); German student Fritz van Briessen published *The Way of the Chinese Brush: Painting Techniques of China and Japan*, Tokyo and Rutland, dedicated to Pu Quan
1963	*Guanting Reservoir – Morning* (cat. no. 22); published *How to Paint Bamboo*
1964	*Viewing the pine trees through clouds in the mist* (cat. no. 23)
1965	*Wu River* with Pu Jie's calligraphy (cat. no. 24)
1971	Paintings by Pu Quan from the collection of Katy Talati exhibited in the Ashmolean Museum, Oxford
1973	Pu Quan's portrait painted by Zhou Sicong (cat. no. 37)
	The Cold Iron Chains of Dadu Bridge, for daughter Chong Jia (cat. no. 25)
1975	Calligraphy, *Long March* (cat. no. 26)
1977	*Morning Sunlight at Ciping* (cat. no. 27)
1978	Pu Quan paintings from the collection of Katy Talati exhibited in Birmingham and at the Victoria and Albert Museum
1979	Exhibition at the China Arts and Crafts Company in Hong Kong
1980	Made official visit to West Germany
	Joint exhibition with Pu Zuo at the Summer Palace, Beijing
1981	Landscape (cat. no. 28)
1984	*Boating on the stream* (cat. no. 29)
1986	*Horses* (cat.no. 31)
	Publishes article 'Basic practices of landscape painting'
	High lands
	Presents Aixin Jueluo Family painting and calligraphy exhibition
	Yue ji, bamboo and rock in collaboration with Pu Zuo (cat. no. 30)
1987	*Thousand Horses*
1988	Death of Ya Shuhe, Pu Quan's wife
1990	Publishes *Landscape painting skill*, Beijing renmin chubanshe, Beijing
	Bamboo with Pu Jie (cat. no. 35)
1991	Died in Beijing, 19 March

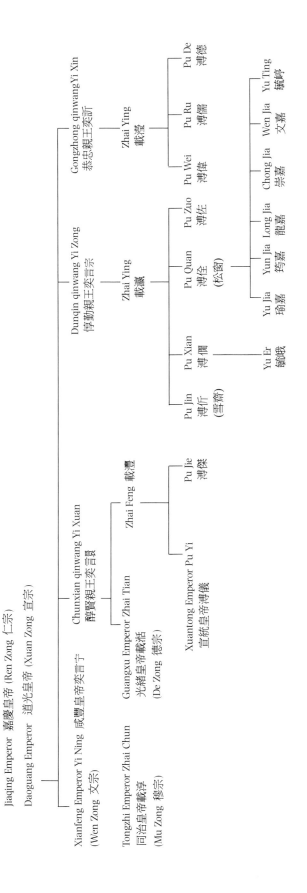

FAMILY TREE

Shunzhi Emperor 順治皇帝 (Shi Zu 世祖)

Kangxi Emperor 康熙皇帝 (Sheng Zu 聖祖)

Yongzheng Emperor 雍正皇帝 (Shi Zong 世宗)

Qianlong Emperor 乾隆皇帝 (Gao Zong 高宗)

Jiaqing Emperor 嘉慶皇帝 (Ren Zong 仁宗)

Daoguang Emperor 道光皇帝 (Xuan Zong 宣宗)

Xianfeng Emperor Yi Ning 咸豐皇帝奕詝 (Wen Zong 文宗)

Chunxian qinwang Yi Xuan 醇賢親王奕譞

Dunqin qinwang Yi Zong 惇勤親王奕誴

Gongzhong qinwang Yi Xin 恭忠親王奕訢

Tongzhi Emperor Zhai Chun 同治皇帝載淳 (Mu Zong 穆宗)

Guangxu Emperor Zhai Tian 光緒皇帝載湉 (De Zong 德宗)

Zhai Feng 載灃

Zhai Ying 載瀅

Zhai Ying 載濚

Xuantong Emperor Pu Yi 宣統皇帝溥儀

Pu Jie 溥傑

Pu Jin 溥伒 (雪齋)

Pu Xian 溥僩

Pu Quan 溥佺 (松窗)

Pu Zuo 溥佐

Pu Wei 溥偉

Pu Ru 溥儒

Pu De 溥德

Yu Er 毓峨

Yu Jia 瑜嘉

Yun Jia 筠嘉

Long Jia 龍嘉

Chong Jia 崇嘉

Wen Jia 文嘉

Yu Ting 毓嶦

96